Exposure
HANDBOOK

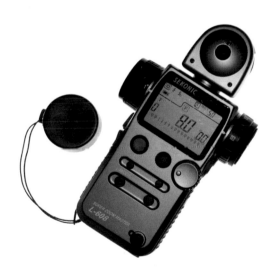

Chris Weston

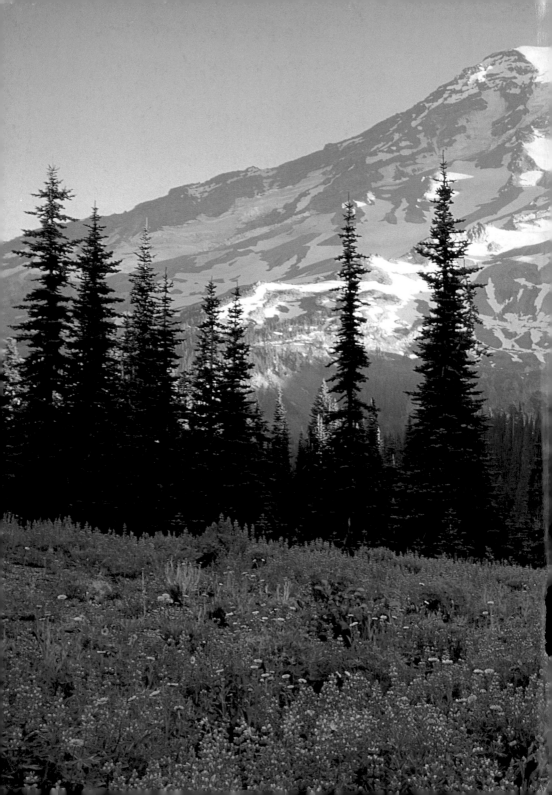

Exposure
HANDBOOK

Chris Weston

photographers'
pip
institute press

First published 2005 by
Photographers' Institute Press / PIP,
An imprint of GMC Publications
166 High Street, Lewes,
East Sussex, BN7 1XU

ISBN 1 86108 430 7

Production Manager: Hilary MacCallum
Managing Editor: Gerrie Purcell
Photography Books Editor: James Beattie
Designer: JoPatterson.com
Artwork: John Yates
Typeface: Frutiger
Colour origination by Masterpiece, London
Printed by Hing Yip Printing Co. Ltd. China

About the author

Chris Weston is a full-time photographer and photojournalist. Chris has photographed elusive animals in some of the most hostile regions of the world and has the proven ability to get the right image time after time.

A regular contributor to numerous magazines and the author of several books, Chris also runs various photographic workshops both in the UK and abroad, through his own company Natural Photographic.

Acknowledgements

I often wonder how many people take the time to read the acknowledgements given in books. I know I am as guilty as any in often skipping this page, eager to get to the main content inside. So I ask, please spare a moment for the following people because without them this book would not exist:

The entire team at PIP for the late nights, long hours and weekends spent toiling over my notes; to Ann and John in South Africa, David in New Zealand, and Chris in Seattle without whom many of these pictures would not have been taken; to Jane and Jim at Intro2020 for the warm welcome I always receive when begging for the use of equipment; Steve and Guy at Bowens International for their thoughts, ideas and, most importantly, for their time. I would also like to pass on my gratitude to those people who dedicate their lives to the protection of many of the animals that I photograph for a living. In particular to Peter at Santago and to everyone at the English School of Falconry, whose creatures appear in this book. And finally, to my darling wife who, beyond any reason I can imagine, still puts up with me after all these years. Again, I am indebted to you all.

Contents

Introduction 8

1

The theory of exposure 14

2

Seeing the light 30

3

Tools of the trade 48

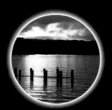

4

Calculating exposure in six simple steps 66

5

What to do when... 90

6

Flash exposure 116

7

Post camera exposure 126

Glossary 134

Appendix 141

Index 142

Introduction

One of the questions I am asked most often on workshops and at seminars is: 'How do I get an accurate exposure?'

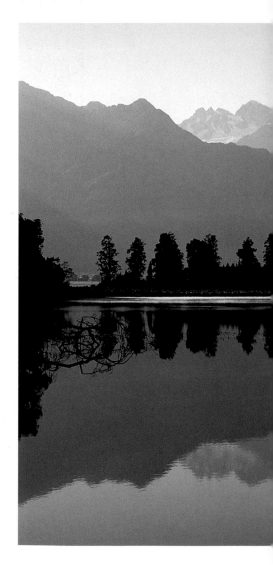

Exposure is one of the fundamentals of the photographic art and yet it remains one of the most mysterious and seemingly complicated aspects of photographic technique. Similarly, the simple question posed above is one of the most difficult to answer. For, while the process of image capture is based on science, photographic exposure is open to artistic interpretation. What one photographer thinks is an accurate exposure, in that it captures the mood or essence of a scene as he or she saw it, another may consider inaccurate if it fails to conform to pre-defined technical rules.

In dealing with the subject of exposure it is as important to illustrate how to control exposure, as it is to explain how to calculate it. Modern cameras, with all their electronic wizardry and computer microchips, have made the technical aspects of exposure much simpler for everyone. What all cameras fail to achieve, however, is an appreciation for the artistry of the person behind the lens. When you point a camera towards a scene it doesn't see what you do, it merely provides a means of recording what you see using silver or pixel.

Below **Light, time of day and weather together pose questions about correct exposure. Lake Mathesson, South Island, New Zealand.**

35mm camera, 50mm lens, Fuji Velvia, 1/20sec at f/22

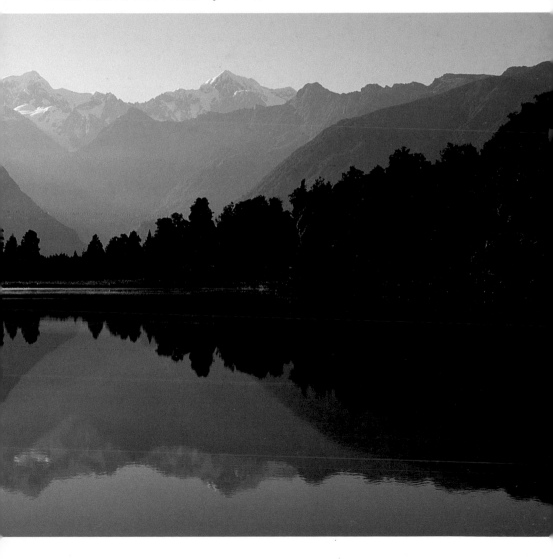

Opposite **Photographic exposure is open to individual interpretation. There is no such thing as a correct exposure, just one that is faithful to the vision of the photographer.**

35mm camera, 100mm lens, Fuji Velvia, 1/60sec at f/5.6

Right **Mastering the art of managing light and the elements of design to communicate a personal vision will help you to produce consistently compelling images.**

D-SLR, 100mm lens, 1/20sec at f/16, ISO-E 200

The role played by the camera is no more than that of vacuous observer, and it will give vacuous results without artistic direction from you.

So what am I saying? I'm saying that in reality there is no such thing as correct exposure and that what we are all striving for in the pictures we make is faithful exposure: an exposure that accurately depicts the scene we saw in our mind's eye and echoes the inner passion that led us to make the photograph at all. The purpose of this book is to provide you with not just another manual on the technicalities of exposure, it is also a guide to controlling exposure as a means of recording your emotional responses to any scene or subject. That means that this book will only be effective with input from you. For me to answer truthfully the question, 'How do I get an accurate exposure?' is contingent on you knowing what effect you are trying to achieve.

To help you along the way I have split the book into three main elements. Firstly, I will guide you through the basic principles of exposure and identify the mechanisms by which you can control it. Next I will discuss how to interpret the data provided by the light meter and how to moderate that data to achieve an image that accurately reflects your vision. Then finally I will look at how to apply this in a wide variety of situations.

Because of the nature of the book, and its intended audience, I have made certain assumptions. Firstly, the aim is that you obtain sufficient knowledge to allow you

Above **The subjectivity of exposure should lead you to ask yourself, 'How would I have photographed that scene differently?' By challenging your perception in this way you will soon begin to master your camera and take control of the images it creates.**

35mm panoramic camera, 45mm lens, Fuji Velvia, 1/6sec at f/16

to control the functions of your camera that relate to exposure. This means that you must use a camera that allows you to control these basic functions. It should allow manual adjustment of lens aperture, shutter speed and ISO or ISO equivalency rating. Second, I have written this book to enable faithful exposures in-camera. Therefore, Chapter 7: Post camera exposure is intended as an overview of exposure adjustments that can be made once the image has been created. Finally, because the majority of photographers today

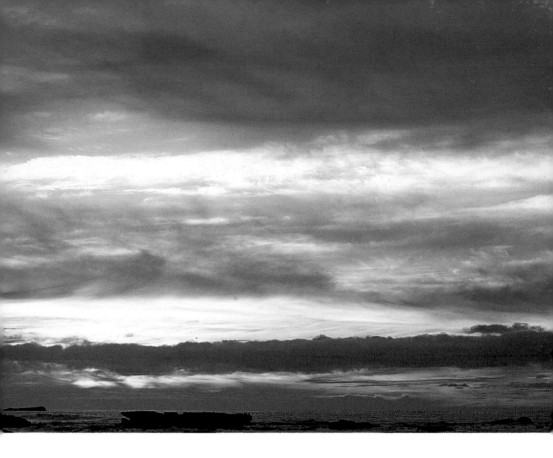

shoot in colour, the emphasis of the book is on colour photography. That said, the guiding principle throughout is to impart sufficient knowledge, beyond that of complex tables and indecipherable logarithms, to allow you to determine faithful exposure settings when you're out in the field or in the studio.

Of course, you may disagree with some of my observations. I encourage you to question my interpretations because by doing so you will become better placed to question your own decisions and selections and become the master of your camera, rather than its slave. As the photographer it is your job to manage the camera in such a way that it captures your photographic imagination. Your knowledge and understanding of light, film and the limitations of a light meter, together with an appreciation of your own photographic direction will open your eyes to the secrets of attaining consistent, faithful exposures.

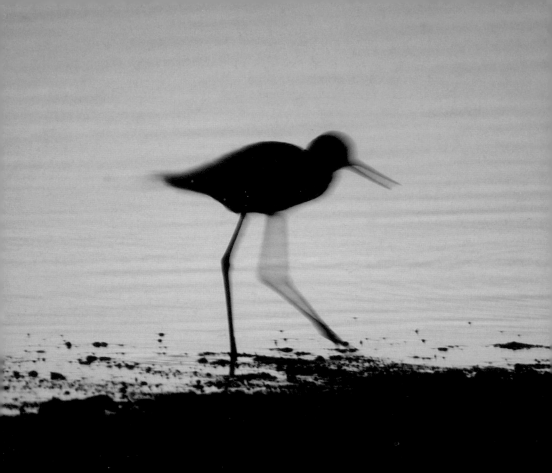

The theory
of exposure

1

Ever since the birth of photography, controlling exposure
has been one of its fundamental disciplines. Despite the
ever-increasing sophistication of camera technology, and changes in
the materials used for image capture, the three principal mechanisms for
controlling exposure remain unchanged. Controlling the sensitivity of the
material, the amount of light reaching that material, and the length of the
exposure is as vital now as it has been throughout the history of photography.

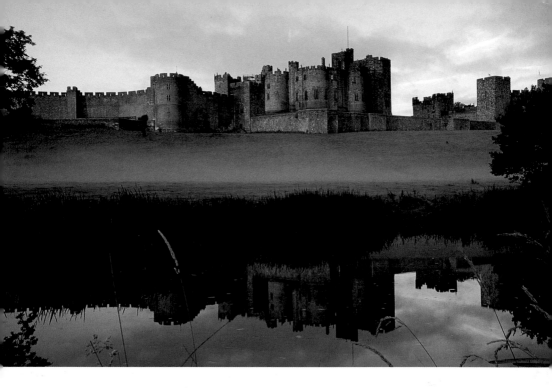

The dictionary describes photography as, 'the process of recording images on sensitized material by the action of light'. How faithfully the image is recorded, in terms of hue, colour and contrast, depends on three things:

1) The **sensitivity** of the material
2) The **amount of light** reaching the sensitized material
3) The **length of time** the sensitized material is exposed to the light

Above **The mist and reflections capture the atmosphere of Alnwick Castle in Northumberland, England.**

35mm camera, 24mm lens, Fuji Velvia, 1/30sec at f/22

Too little light and/or too short a time will result in underexposure – a dull, dark image lacking detail in shadow areas. On the other hand, too much light and/or too long a time will result in overexposure – a washed-out image lacking detail in highlight areas. The trick is to get just the right amount of light for the correct length of time, given the sensitivity of the material, to record the scene as you interpret it.

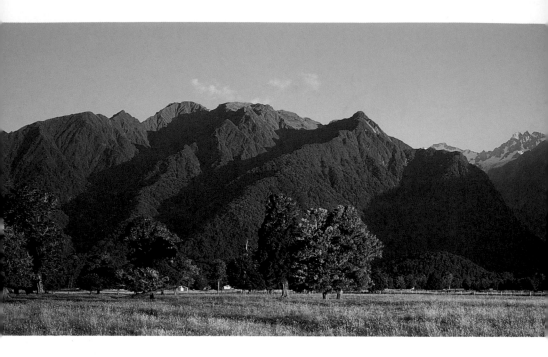

Above **This high-contrast image of the Westland/Tai Poutini National Park in New Zealand, balances the highlights and dark shadow areas to give the scene a three-dimensional appearance.**

35mm panoramic camera, 45mm lens, Fuji Velvia, 1/30sec at f/16

To achieve faithful exposure the camera provides you with three basic controls:

1) ISO (ISO equivalency) rating
2) Lens aperture
3) Shutter speed

All three controls can be adjusted independently. However, each is interdependent on the others and understanding their relationship is the basis for understanding exposure control.

The standard measurement for exposure is the stop. Any doubling or halving in ISO rating, aperture or shutter speed is referred to as a one-stop change. For example, an ISO 200 film is referred to as being one-stop faster than an ISO 100 film, a change in aperture from f/5.6 to f/8 is a one stop decrease, and a change in shutter speed from 1/125sec to 1/250sec is considered to be a one-stop increase.

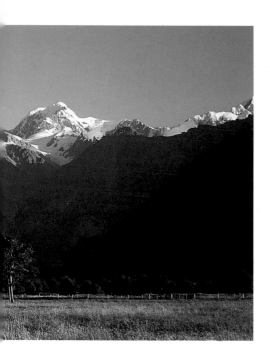

ISO rating

The ISO (International Standards Organisation) rating is the standardized measure of a film's sensitivity to light. A film with a low ISO rating, such as Fuji Velvia 50 or Kodachrome 64, is less sensitive to light than a film with a higher ISO. In practical terms this means a low-ISO film needs brighter light, more light or a longer period of time, for a correctly exposed image to form on it, than a film with a higher ISO rating would need. Low-ISO films are often referred to as 'slow' films and high-ISO films as 'fast' films.

ISO ratings follow a geometric progression. Every doubling in the ISO rating halves the amount of light required for an image to form. Likewise, every time an ISO rating is halved the amount of light required for an image to form doubles.

In digital cameras film is replaced by a sensor, such as a CCD (charge-coupled device) or CMOS (complementary metal oxide sensor), its sensitivity is measured in the same units as film, and is referred to as its ISO equivalency. Therefore, a sensor set to an ISO equivalency of 200, for example, will react to light in much the same way as an ISO 200 film would.

One of the advantages of digital cameras is that you can alter the ISO equivalency of the sensor on a shot-by-shot basis, choosing the best setting for each situation. While you can also alter the nominal rating of a film by changing the film-speed

TABLE 1	ISO (ISO EQUIVALENCY) RATING					
	Slow					**Fast**
ISO rating	50	100	200	400	800	1600

setting on the camera this will not change the sensitivity of the film, rather it will change the way your camera exposes the film. This will lead to deliberate under- or overexposure known as pushing and pulling, which can be corrected when the film is developed. The effect this has on exposure and the final image, and why you might choose to do it will be discussed later in the book (see page 69).

Lens aperture

The lens aperture is the hole that controls the amount of light reaching the film or sensor at any given moment. In isolation it works in the same way as the pupil in a human eye, contracting in bright conditions as less light is needed to distinguish detail and expanding in dark conditions to allow sufficient

light in. Changing the size of the aperture allows you to decide how much light reaches the film at any given moment.

All camera lenses are calibrated to the same scale of measurement known as f-stops. These can be seen on the lens aperture ring and are shown in the LCD panels of modern cameras. The range of f-stops varies depending on the lens but always forms part of the same scale, illustrated in table 2 opposite.

Below **Lens aperture is determined by the size of the hole through which light passes. Smaller apertures, denoted by larger f-numbers (f/16, f/22, f/32, etc.), give the greatest depth of field, while large apertures, denoted by small f-numbers (f/2, f/2.8. f/4, etc.), produce limited depth of field.**

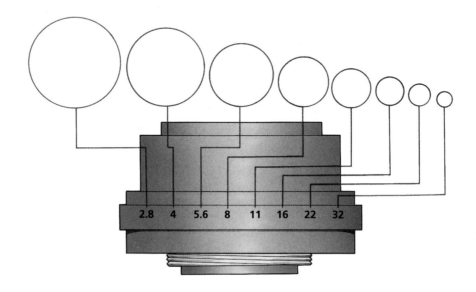

2.8 4 5.6 8 11 16 22 32

TABLE 2 f-STOP INDEX										
Wide										**Narrow**
f/1.4	f/2	f/2.8	f/4	f/5.6	f/8	f/11	f/16	f/22	f/32	f/45

The way that f-stops are written refers to the relationship between the focal length of the lens and the diameter of the aperture. For example f/2 means that the diameter of the aperture is half the focal length of the lens. The larger the f-stop number the smaller the aperture, as depicted in the illustration on page 18. Increasing the aperture by one stop – such as from f/8 to f/5.6 – doubles the amount of light reaching the film/sensor, while reducing the aperture by one stop will halve the amount of light reaching the film/sensor.

Controlling exposure via aperture affects the depth of field. The larger the aperture (small f-stop numbers) the less depth of field you will have to work with, while reducing the aperture (large f-stop numbers) increases the available depth of field. This will affect how the final image appears, and should be taken into account when setting your exposure values and composing the image (see chapter 4).

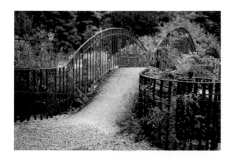

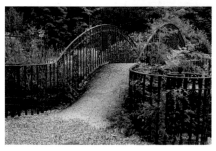

Above top **In this image the aperture has been set to f/4. The smaller aperture has resulted in a shallower depth of field, which has led to a loss of sharpness.**

Above **In this version of the image a small aperture of f/32 has given enough depth of field to render the whole bridge sharp.**

Shutter speed

The final controlling factor in the exposure equation is shutter speed. Shutter speed defines the length of time that light falls on the film/sensor and is measured in seconds or fractions of seconds. Most cameras have a range of pre-set shutter speeds (see table 3) and an additional B(ulb) or T(ime) setting. In the bulb setting the shutter remains open so long as the shutter release is depressed, while in the time setting the shutter will open when you first press the shutter-release button and then close when you press it a second time. Bulb and time settings enable you to use exposure times longer then the slowest pre-defined camera setting.

As with changes in aperture and ISO, a one-stop change in shutter speed will either double or halve the exposure. For example, an increase in shutter speed from 1/125sec to 1/250sec will halve the length of time the shutter is open, causing a one-stop decrease in exposure. Correspondingly, decreasing the shutter speed from 1/125sec to 1/60sec doubles the length of time that the shutter is open, increasing the exposure by one stop.

Controlling exposure via shutter speed gives you control over how movement is depicted. A fast shutter speed will tend to freeze action, while a slow shutter speed will create blur, giving the subject a sense of motion. Obviously this depends on the relative speed and direction of the subject, a fast moving subject will require a faster shutter speed to freeze its action than a slower one.

Opposite **The shutter speed that you choose will determine how motion is depicted in your photographs. Using a fast shutter speed (1/500sec) helped to freeze the action of these Cape buffalo as they stampeded up the riverbank away from predatory danger at their crossing point.**

TABLE 3 — COMMON SHUTTER SPEEDS

Slow

B(ulb) or T(ime)	30 secs	15	8	4	2	1	1/2	1/4	1/8	1/15	1/30

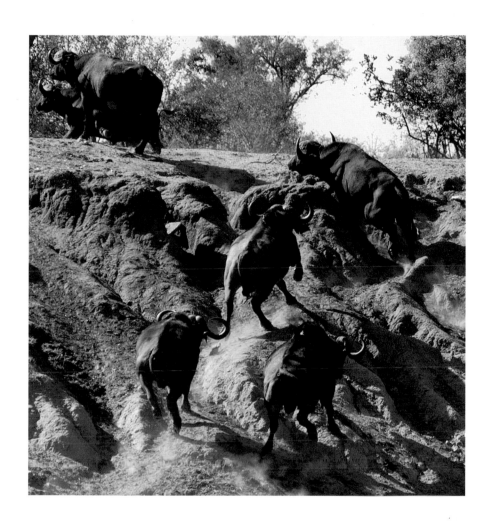

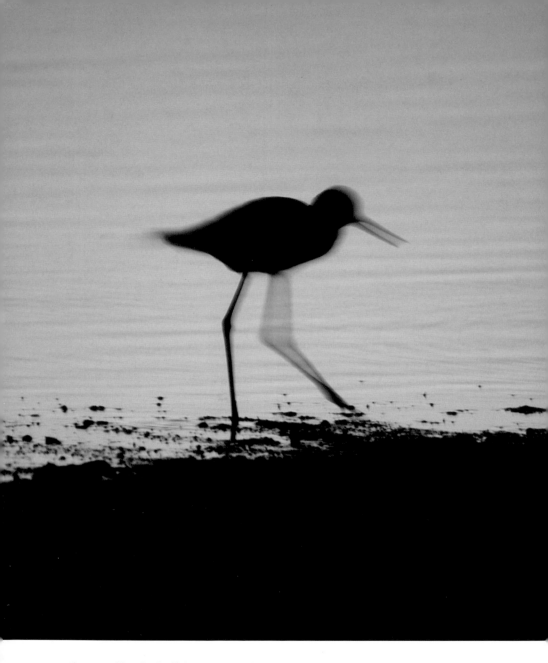

Above **Unlike the buffalo image on the previous page I purposely used a slow shutter speed of 1/15sec to record the motion as a blur.**

Using all three controls together

Setting faithful exposures requires an understanding of the relationship between the three exposure controls.

When not enough light reaches the film/sensor underexposure will occur. To correct this you can increase the aperture (known as, 'opening up the lens') or decrease the shutter speed. Either of these will increase the amount of light falling on the film/sensor. Alternatively, you can increase the ISO equivalency of a digital sensor, choose a higher ISO film, or 'push' a roll of film to a higher nominal ISO (see page 69).

Too much light reaching the film/sensor causes overexposure and you will need to reduce the level of light by decreasing the aperture or making the shutter speed faster. You can also decrease the ISO rating of a digital sensor, select a lower ISO film, or 'pull' a film to a lower nominal ISO.

Once you have selected the appropriate overall exposure value, any change in one variable needs to be compensated by an equal and opposite change in one of the others. For example, take a base exposure of 1/125sec at f/8 at ISO 100, if you want to increase the shutter speed to 1/250sec (halving the amount of time light reaches the film/sensor) without changing the overall exposure value you can increase the aperture to f/5.6 (doubling the amount of light reaching the film/sensor). You can alternatively increase the sensitivity

TABLE

4

LENS APERTURE / SHUTTER SPEED / ISO (ISO EQUIVALENCY) COMBINATIONS THAT PRODUCE IDENTICAL EXPOSURE VALUES

Lens aperture	Shutter speed (seconds)	ISO (ISO equivalency) rating	Exposure value (EV)
f/4	1/250	200	11
f/4	1/125	100	11
f/4	1/500	400	11
f/2.8	1/250	100	11
f/5.6	1/250	400	11

of a sensor to ISO 200 or choose an ISO 200 film. The reciprocal nature of these changes means that this characteristic of exposure is known as the law of reciprocity.

What the law of reciprocity expresses is that exactly the same amount of light falls on the film/sensor at various different aperture, shutter speed and ISO settings, so long as any change in one variable is compensated for by an equal and opposite change in another. The sample table 4 demonstrates how a whole range of different combinations can produce the same overall exposure value.

The image above is underexposed. This has been corrected in the image below by using a slower shutter speed.

Above *1/125sec at f/5.6 – ISO equivalency 200*

Below *1/60sec at f/5.6 – ISO equivalency 200*

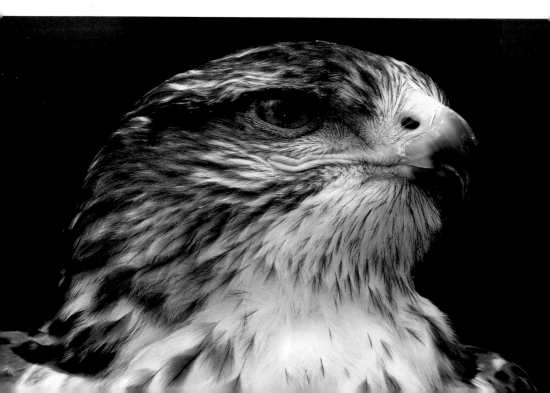

RECIPROCITY LAW FAILURE

While the law of reciprocity is a great rule of thumb, it sometimes fails. This is known as reciprocity law failure and can occur with shutter speeds over one second.

The law of reciprocity states that any change in one exposure variable is offset by an equal and opposite change in another. For example, an exposure of 1/125sec at f/8 will give the same exposure as 1/60sec at f/11. However, film, and to a lesser extent sensors, become less sensitive the longer they are exposed. So, when shooting with shutter speeds over one second, you must allow more light in to make up for the loss in sensitivity. The table on page 104 gives guidelines for different films.

Digital exposure

Since digital capture technology has become more popular I have often been asked questions about how it differs from film photography. Firstly, I would like to point out that digital photography is still photography and, for the most part, whether you capture an image on pixels or on film is really neither here nor there. Having said that, there are a number of exposure-related issues that specifically affect digital cameras.

For me the best thing about digital photography is that you now have far more control over the in-camera image than you ever had with film. There are a host of useful features that many digital cameras offer such as the ability to change the ISO rating of the sensor on a shot-by-shot basis whereas film can only be 'pushed' or 'pulled' for the whole roll. You are also able to check exposures using the rear LCD panel, whether by looking at the image itself, the highlight warnings or the exposure histograms. This ability to check and re-shoot images if necessary means that you get far more shots 'in the bag' at the end of a day's shoot.

Another bonus is that the latitude of some sensors is even greater than negative film, and this can make dealing with high-contrast scenes far simpler. Having said that the latitude of a sensor, unlike that of film, tends not to be evenly distributed and digital sensors retain more detail in shadow more than they do in highlights. This means that highlights can sometimes 'burn-out' especially in bright conditions, rendering them as pure featureless white. To prevent this happening I often underexpose from the suggested meter reading by −1/3 stop.

Working with exposure

Why take the trouble to set apertures and shutter speeds yourself? Why not just switch your camera to auto and let it select the appropriate settings? The answer is that aperture and shutter speed settings can control the way the subject appears in the final image. Aperture, which controls depth of field, can be used to include or isolate areas of foreground and background, either focusing attention on the main subject, by placing it in isolation, or creating a sense of place by rendering the foreground and background sharp. The shutter speed defines the appearance of movement. Faster settings freeze motion and keep the subject sharp with well-defined details. A slow shutter speed, on the other hand, can blur motion giving the subject less defined details but adding visual energy to your image. Again there is no right or wrong in exposure, the best way of finding what works for you is to experiment.

Doing it yourself

A lot of time, money and effort has been spent over the past few years by the research and development departments of the major manufacturers in attempting to develop the ultimate light meter. It is also fair to say that some have come close. Currently, I use Nikon's F5 and D2H cameras and they both have extremely accurate and flexible metering systems.

However, as with any system designed to work in diverse conditions, camera light meters have to work either on averages or by recognizing scenes compared with preset precedents. This normally works, but if you want to make pictures that are better than average you must learn how to cope with extremes, which is something a camera just can't do on its own.

More sophisticated cameras have many scenes and values in their memory, the issue is one of recognition. It's all very well having

Too much light for too long a time will result in your photographs appearing too bright and washed out, like the image below. Reducing the aperture or ISO rating of the film/sensor, or increasing the shutter speed will show more detail, as in the image opposite.

Below *1/30sec at f/5.6 – ISO equivalency 200*
Opposite *1/60sec at f/5.6 – ISO equivalency 200*

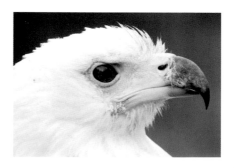

1 ○○○○○○○

a look-up table to get the 'correct' exposure, but how does the camera know whether it is looking up the right information? In reality it cannot; it often gets it right, but the difficulty from the photographer's point of view is that you can never be sure until you see the finished product or, in the case of digital cameras, the review image. If you want to make consistently good photographs you should use exposure readings as a base, but also learn to make the camera record scenes as you wish. Every change to a camera's settings changes the final image. Not only will those changes affect things like depth of field, motion blur and graininess (or noise in the case of digital), they will also affect the graphic statement within the frame. Sometimes these differences will only be subtle but they are what make your photographs your personal statement, and also what makes the difference between a good picture and a compelling one.

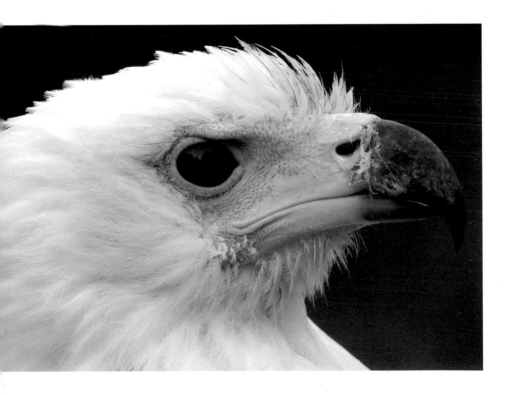

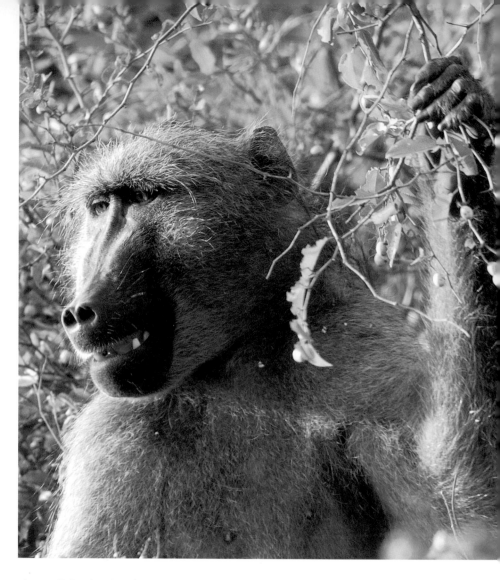

Above **Slight changes in lens aperture, shutter speed or ISO rating can massively alter the statement a photograph makes. This image was shot using aperture priority autoexposure.**

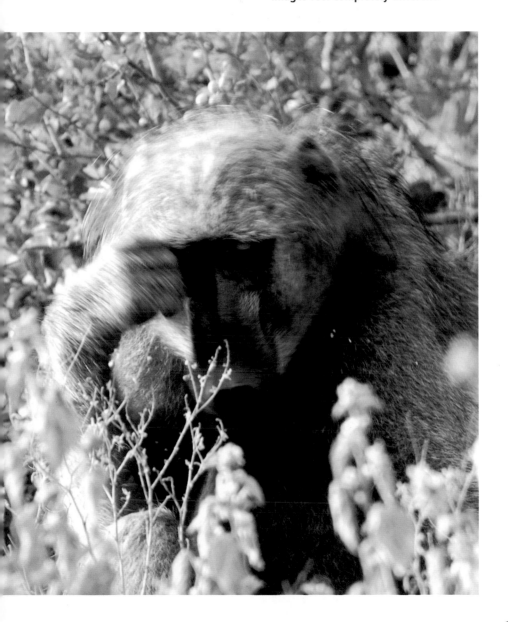

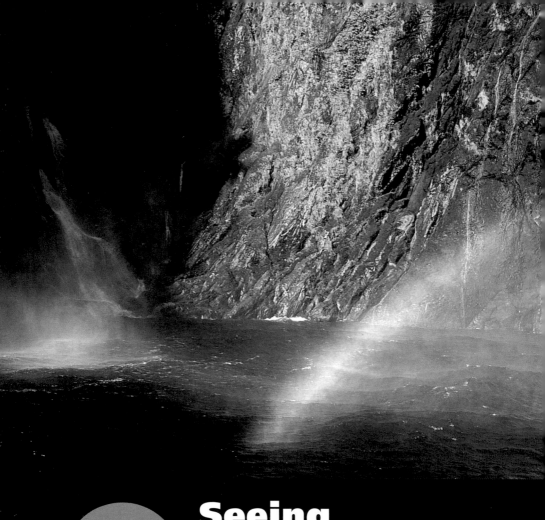

Seeing
the light

2

When you first start learning about photography
invariably you read about the 'quality' of light.
But what does this really mean in a practical sense? Light is
crucially important for photographers, both in terms of quantity and quality.
Learning how to see and read light will not only make understanding
exposure far simpler, it will also improve the quality of your photographs

Light at work

If you studied physics at school then you will probably be familiar with the basic characteristics of light. However, if like me you have forgotten most of your lessons, here is a quick refresher.

People and cameras see light in terms of waves. There are many different types of waves on the electromagnetic spectrum but only a fraction of them are visible to the naked eye. These visible waves also have different frequencies and it is these frequencies that give us variations in colour.

Below **This diagram illustrates some of the electromagnetic spectrum and the small part of it that forms visible light. Some of the other wavelengths you will know, such as radio waves and heat, while others you will recognize in photographic terms, such as ultraviolet light and infrared. The principal colours of the visible spectrum – violet, blue, green, yellow, orange and red – are commonly seen in rainbows.**

The colour of light

We can decipher many millions of colours but all of them are a combination of some or all of the six principal colours of the visible light spectrum – red, orange, yellow, green, blue and violet. If you were to mix all six in equal proportions you would get white, colourless light.

Film, digital sensors and computer monitors create colours by a similar means, mixing red, green and blue to achieve a wide range of colours. For example, an equal mix of blue and green will produce cyan; red and blue will produce magenta; and green and red will produce yellow. Mixing all three colours equally will give you white. On the other hand ink jet printers and photographic enlargers produce colour by subtraction. Look at the dials on a colour enlarger and you will see cyan, magenta and yellow. By mixing yellow and cyan you get green; cyan and magenta will give you blue; and magenta and yellow gives you red. Combine all three and you get black. Another photographic example of colour by subtraction is colour correction

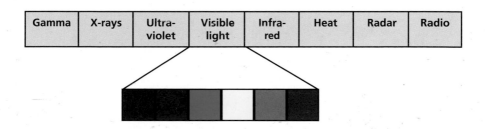

Gamma	X-rays	Ultra-violet	Visible light	Infra-red	Heat	Radar	Radio

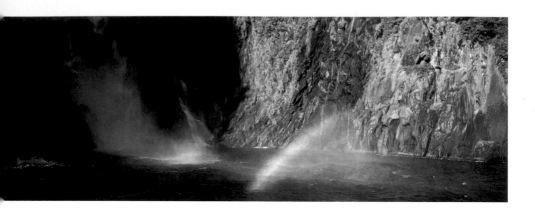

filters. For instance, placing an '81 series' orange filter in front of your lens will absorb some of the blue light that predominates during the middle of the day leaving warm red and neutral green light to produce a much warmer overtone in the resulting image.

Above **These rainbows taken at Milford Sound on the South Island of New Zealand, display the whole spectrum of visible colours.**

35mm panoramic camera, 45mm lens, Fuji Provia, 1/60sec at f/8

The colours we see are created either by addition (below left) **or subtraction** (below right)**, as shown in these diagrams.**

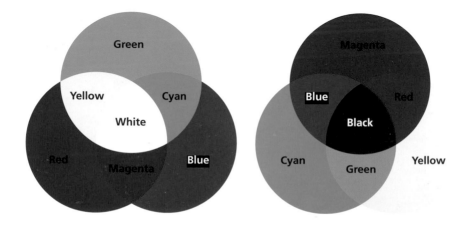

Blowing hot and cold

I used the term 'warmer' before because colour is often described in terms of its apparent temperature. Warm colours, such as orange, red and yellow are the colours you see at sunrise, in the early morning and at sunset. People associate warm colours with positive emotions. Conversely, blue is a cool colour, and photographs with lots of blue in them can make you feel chilled, which can be used in photographic composition when that is the response you are trying to provoke – in a winter landscape, perhaps.

However, colours can be described using a more accurate colour temperature, which is measured on the Kelvin scale, in degrees Kelvin (K) – see table 5, below. Its relevance to your photography, beyond its compositional properties, is in how film and digital sensors respond to light. The human eye is very sophisticated and automatically compensates for differences in

TABLE 5 COLOUR TEMPERATURE OF LIGHT SOURCES

Light source	Temperature (K)
Clear blue sky	10,000 – 15,000
Shade on sunny day	7,500
Overcast (cloudy) day	6,000 – 8,000
Noon sunlight	6,500
Average daylight (4 hours before sunset and 4 hours after sunrise)	5,500
Early am / late pm	4,000
1 hour before sunset	3,500
Sunset	2,500
Electronic flash	5,500
Fluorescent light	4,200
Household light bulb (100W)	2,900
Studio tungsten light	3,200
Candlelight	2,000

Above **Compare these two images and decide which scene you would prefer to be walking in. People have a natural preference for the warmer colours of the spectrum, and images using 'warm' tones can evoke positive emotions.**

colour temperature so that you rarely notice much of a change. Photosensitive materials are less capable of such compensation, which means, for example, that the blue colour cast – invisible to you – during the middle of the day is recorded on film/sensor exactly as that – blue colour. Most film and, to some extent, digital sensors are calibrated to read light as average daylight and record colour based on their pre-defined settings.

This means that any light source other than average daylight (four hours after sunrise and four hours before sunset), which is measured at 5,500K, will be recorded with either a cool cast (above 5,500K) or with a warm cast (below 5,500K).

Below **Sometimes colour casts produce preferable results and compensating for the effects of a golden sunset on daylight-balanced film may produce an effect you would rather avoid.**

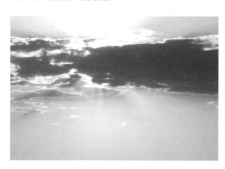 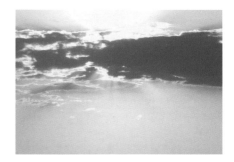

TABLE 6
RECOMMENDED FILTERS FOR COLOUR CORRECTION

Light source	Colour correction filter (daylight-balanced film)	WB setting (digital)
Clear blue sky	85B	Shade
Shade on sunny day	81C	Shade
Overcast (cloudy) day	81B	Cloudy
Noon sunlight	81B	Cloudy
Average daylight (4 hours before sunset and 4 hours after sunrise)	81A	Cloudy
Early am / late am	81A	Cloudy
1 hour before sunset	81A	Cloudy
Sunset	None	Cloudy
Electronic flash	None	Flash
Fluorescent light	82C	Fluorescent
Household light bulb (100W)	80A + 82C	Incandescent
Studio tungsten light	80A	Incandescent
Candlelight	None	Incandescent

Sometimes, the effect of this colour cast is pleasant, for example you would not want to correct and therefore neutralize the warm cast of a sunset. At other times you may want to add some colour correction. Usually, this when photographing with artificial light using daylight-balanced film or when the colour temperature is much higher than the average 5,500K.

Above **In table 6, I have listed some of my own preferences for using colour correction filters, which you are welcome to copy. As always, please remember that they are personal choices and you may want to experiment with your own ideas.**

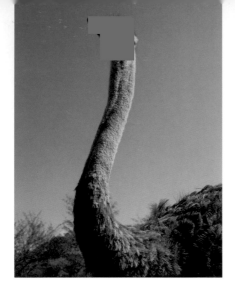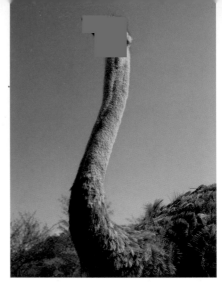

Above **There are times when the 'invisible' colour of light will need to be rectified by using colour correction filters or digital white balance. For example, look closely at the two images of the ostrich. Both were taken with a digital camera, the first with WB set to daylight. Changing the setting to 'cloudy' has added a touch of warmth to the picture that greatly enhances its appeal.**

White balance (WB)

The advent of digital technology has given a far greater level of control to photographers than is available with film. For example, while film can be balanced only for a single colour temperature (usually daylight or tungsten light), digital sensors can be balanced to a different colour temperature for each shot.

Many digital cameras come with WB settings pre-programmed, the more common of which are listed in table 7, along with their relative colour temperature equivalents. More advanced digital cameras also allow you to match exactly the colour temperature at the point of shooting, which gives you the greatest level of control over the colour balance and the way colour appears in the image.

As you will see from table 6 (see page 35) I often use a WB setting other than that recommended by the camera. For example, under average daylight conditions I will set the WB to 'cloudy' rather than 'direct sunlight'. This is because, more often than not, my style of photography dictates that my images should have a warm colour cast. Again, this is a personal preference and, to some extent, a commercially based decision. Whether you follow my lead is a conclusion you must come to based on your own experience and experimentation.

TABLE

7

WHITE BALANCE PREFERENCES

WB setting	Approximate colour temperature (K)	
Incandescent	3,000	(tungsten light bulb)
Fluorescent	4,200	(fluorescent tube lighting)
Direct sunlight	5,200	(a similar setting to daylight-balanced film)
Flash	5,400	
Cloudy	6,000	
Shade	8,000	

Incandescent

Fluorescent

Direct sunlight

Flash

Cloudy

Shade

Intensity and contrast

Another important facet of photography, particularly in relation to exposure, is the intensity of light. Light intensity is determined by the size of the light source and its distance from the subject.

Sunlight

Sunlight is effectively a fixed distance light source. However, the effective size of sunlight can vary. Direct sunlight (that seen on a cloudless day) is considered a small, point light source. The reason for this is that although, in physical terms, the sun is very big its vast distance from the earth reduces its size relative to objects on the earth's surface. On an overcast day, when the direct rays of the sun are scattered into many new straight lines of light by the cloud cover, the sun becomes a large light source, which produces a very different quality of light – more on that later.

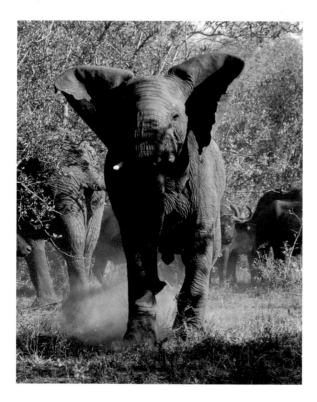

Sunlight can be either a point source, creating hard shadows and contrast (left) **or, on overcast days, a large light source, creating a much softer quality of light that reduces contrast and produces less well-defined shadows** (opposite).

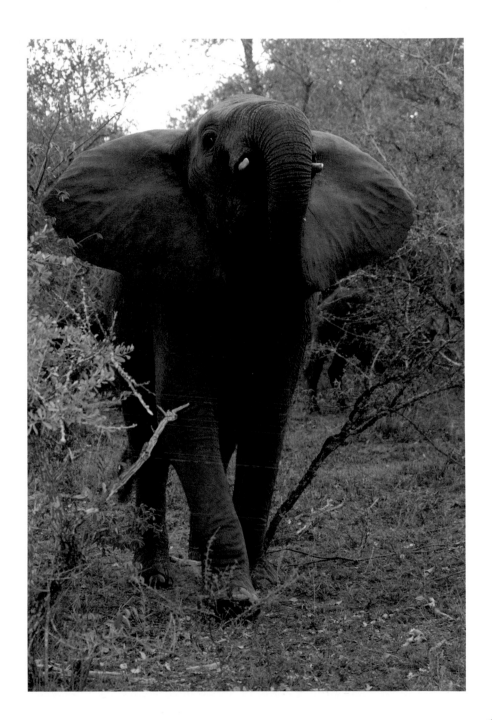

Artificial light

With artificial light you get to play God, with complete control over both the size of the light source and its distance from the subject, and any changes you make can have a distinct effect on the intensity of light falling on your subject. For example, while moving a few steps closer to a waterfall will make very little difference to your exposure settings, moving a studio light the same distance closer to your subject will change your exposure drastically. Distance will also determine the size of the light source in studio photography. A small, point light source, such as a studio reflector, for example, can become a large light source when placed very close to a small subject. Putting a diffuser, such as a soft box, over a point light source will also change the size of the light source, in the same way that cloud cover changes the relative size of light from the sun. Doing so will also change your exposure settings, even if the light to subject distance remains unaltered.

Below **Like sunlight, artificial light can be either hard or soft in quality. Compare these two images and see how the soft lighting used in the left picture creates a gentler effect than the hard lighting used on the right.**

Contrast

One key factor of photography that is influenced by the intensity of light is contrast. Contrast is the measure of the difference between the highlights and shadows in a given scene. Once again, this is an area where our own eyes are our worst enemy. Humans are capable of seeing detail in both highlights and shadows with a high degree of latitude. Film and digital sensors, however, have limited latitude and so, when calculating exposures, you must learn to see like the medium you're using to record the image. Contrast is greater under direct lighting conditions, such as those created by point light sources (such as the sun) and when that source is directly to the side or above the subject. Under diffused conditions, and when the source is in front of the subject, contrast is reduced.

Below **Contrast, while sometimes difficult to work with, gives your images three-dimensional form by emphasizing contours. Look at these two pictures and study how the direction of the light has changed the appearance of the model. In the left image, the lighting has produced a very flat picture with little contrast. In the image on the right the lighting has been changed to create shadows on one side of the model's face, which accentuates her form.**

Quality

Something else you will notice, depending on the lighting conditions, is the quality of the light. Point light sources produce shadows that are harsh and well defined and are described as having a 'hard' quality. Diffused light sources, on the other hand, produce shadows that are much softer with less well-defined edges and are referred to as having a 'soft' quality. The quality of light greatly affects the way your subjects appear in photographs and, while there are always exceptions to the rule, certain subjects are reproduced better under complimentary and sympathetic conditions. For example, portraits of people rarely look pleasing in hard light conditions, while landscape photographers often prefer well-defined shadows that can create very evocative images.

Below **Shadows that are formed when light falls from the side of your subject create form and depth that can be exploited by landscape photographers.**

D-SLR, 50mm lens, 1/125sec at f/16, ISO-E 200

The direction of light

The final element I'm going to consider in this chapter is the direction of light. Once again, this is a key element to how your subject appears in the final image. Photographs are two-dimensional and yet the world around us is three-dimensional. How, then, do you cross the chasm between the two? The answer is in using the direction of light to create the effects you want. Typically, light comes from one of four places: the side, above, in front and behind.

Front lighting You are probably all too familiar with the old saying, 'Always photograph with the sun behind you.' Such advice was coined when photography first became fashionable and open to everyone, (rather than just scientists) and had more to do with the limitations of consumer cameras like the Kodak Box Brownie than it had to do with good photography. Lighting a subject from the front will produce acceptable images but often those images will appear very flat and lacking in form. Front lighting also reduces contrast, which can remove the appearance of texture, although this same disadvantage becomes advantageous when you are simply trying to record subjects' key features.

Side lighting If you are trying to create the appearance of a three-dimensional image then side lighting is going to be your preferred option. Lighting that falls on a subject from the side creates shadows that punctuate texture and define the sides of multi-dimensional objects, such as buildings. It is these shadows that give form to your photographs and help to turn them from flat pieces of paper into pictures with high visual energy.

Lighting from above Overhead lighting is typical of the light you'll encounter in the middle of the day and is avoided by most photographers, particularly if that light is of a 'hard' quality. However, there are occasions when you can turn light from above to your advantage. If, for example, your subject has texture that is horizontally formed then direct lighting from above will produce small shadows below each undulation that will help to emphasize form.

Back lighting Ignoring the age-old advice never to shoot into the sun can produce some of the classic compositions in photography, such as silhouettes and the 'golden halo' of rim light around a subject. Getting this effect right depends on your ability to get the exposure right, which is what the rest of this book covers.

Above **Front lighting tends to produce flat images that lack contrast and apparent depth. However, it does have its uses especially if you are trying to produce a photograph that is a 'straight' record.**

Above **Lighting from above can accentuate linear texture, by creating shadows below each undulation. This is particularly useful if that texture is an important element of the subject.**

Opposite **Side lighting is the best form of lighting for creating three-dimensional images that highlight form as well as texture.**

Below **Back lighting can help create powerful photographic compositions and at its extreme produces detail-free shadows to form silhouettes.**

Tools of the trade

3

Now that we've covered the theory of exposure it's time to look at the practice. There are plenty of different ways of taking exposure readings and plenty of tools to take them with. The secret is to choose the equipment that is best suited to what you want to do, so in this chapter we'll look at what each piece of equipment does and how it does it. Hopefully this will give you some idea of when is the right time to employ which tool.

Reflected light meters

When we look at a subject, other than directly at a light source, what we see is reflected light. This light is measured with a reflected light meter (also known as a luminance meter). A subject's brightness is determined by the amount of light it reflects and a reflected light meter converts this light into values that can be interpreted by the photographer to calculate exposure settings. This may be in the form of an exposure value (EV) or in the form of an actual aperture/shutter speed combination, depending on the meter used.

One of the main advantages of the reflected light meter is its practicality. Because you are measuring reflected light you don't need to be close to the subject, a definite advantage if, like me, you photograph large predatory animals. This also means that the

Below **A correct exposure has kept the detail in these boat-buildings on Lindisfarne, Northumberland, England.**

35mm camera, 24mm lens, Fuji Velvia, 1/50sec at f/16

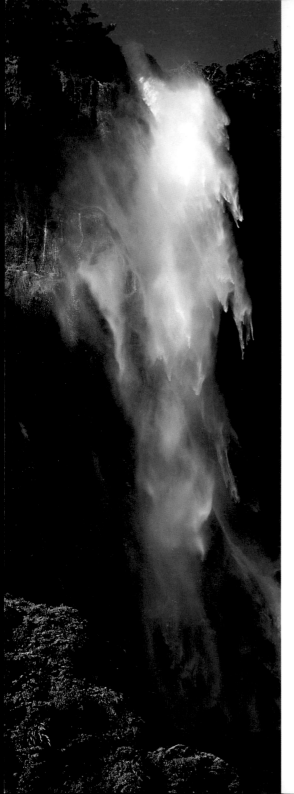

Using the right light meter in the right way is essential for calculating faithful exposures of scenes such as this one, taken at Stirling Falls, South Island, New Zealand.

35mm panoramic camera, 45mm lens, Fuji Velvia, 1/200sec at f/8

meter can be built into the body of the camera, normally as through-the-lens (TTL) metering.

The main disadvantage of reflected light meters, including TTL meters, is that they are calibrated to 'see' everything as an average, or middle tone – often known as 18% grey. However, different subjects reflect different amounts of the light falling on them (for example a yellow daffodil flower will reflect more light than a dark green conifer tree). What this means in practice is that the meter will assume that the subject is reflecting 18% of the light falling on it and will give a reading based on that assumption. However, any subject that is lighter or darker than mid-tone, such as white or black, will reflect more or less light, respectively. The reflected light meter will then be tricked into providing an inaccurate reading and, in this example, whites and blacks will come out grey in the final image. For a practical example see pages 52 and 53.

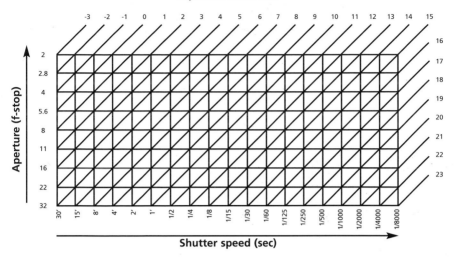

Exposure value (EV)

Aperture (f-stop)

Shutter speed (sec)

Above **Some meters give an exposure calculation as an EV number. This number can be referred to the diagram above to determine the correct combination of camera settings. For example, an EV of 8 would be the equivalent of 1/60sec at f/2, 1/30sec at f/2.8, 1/15sec at f/4, and so on.**

Reflected light meters, such as in-built TTL meters, read the light reflecting off a subject. They are the most practical form of photographic light meter and, arguably, the most accurate.

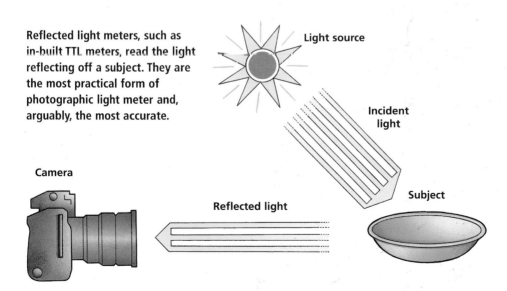

Light source

Incident light

Camera

Reflected light

Subject

This white bench was first photographed with the camera set to autoexposure and is underexposed. The light meter has rendered the subject as mid-tone grey. By adding two stops of compensation, the more natural second image has been achieved.

Above *1/60sec at f/8 – ISO 50*
Below *1/30sec at f/5.6 – ISO 50*

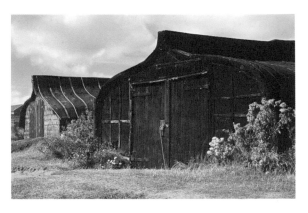

Similarly, this picture taken on Lindisfarne, Northumberland, shows the black building being rendered grey by the autoexposure meter. Reducing the exposure by two stops has darkened the image, giving a more realistic representation of the scene.

Above *1/60sec at f/16 – ISO 50*
Below *1/250sec at f/16 – ISO 50*

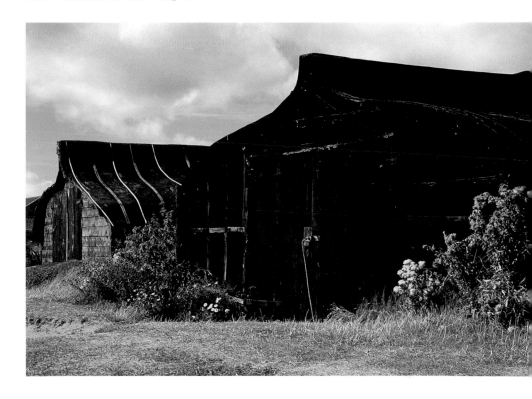

Multiple-function exposure systems

When TTL metering was first introduced it was quite basic compared to more modern systems. Most TTL meters today offer three types of system: multi-segment, centre-weighted, and spot metering.

Multi-segment metering As its name suggests, a multi-segment metering system takes several readings from different areas of the scene and calculates a reading based on a combination of factors. Depending on the sophistication of the system it will incorporate these readings with other information based on subject distance, subject position, colour information and sometimes a database of pre-stored information.

This type of metering system is often the most accurate when photographing a scene where the level of contrast falls within the latitude range of the film used and where there is an even distribution of middle tones.

Centre-weighted metering

When used in centre-weighted metering mode a TTL meter reads the light across the whole scene but weights the reading towards the central portion. Usually around 75% of the reading is based on a centre circle about 12mm in diameter, although some cameras allow you to change the diameter of this circle. This is ideal for portrait photography, where the subject stands out from the background and fills a large portion of the image space.

Above **Multi-segment TTL meters take data from many areas of the viewfinder and calculate an exposure value based on the findings, sometimes in relation to a database of actual images stored in the camera's memory banks.**

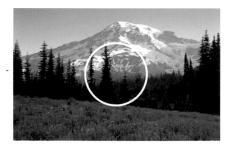

Above **Centre-weighted metering systems weight most of the exposure calculation in the centre circle of the viewfinder. This is useful if the subject fills the centre of the frame. It also takes into account some of the surrounding scene.**

Spot metering When set to spot metering mode, the TTL meter takes a reading from a very small part of the scene. This allows for very precise metering of specific areas and provides the greatest level of creative control over your exposure settings. It is particularly useful when dealing with high-contrast scenes and scenes where the intensity of light is diverse.

Hand-held reflected light meters

If your camera has a built-in TTL meter you might ask why you would want a hand-held meter as well. The answer is that hand-held meters are more physically versatile. With a hand-held meter there is no need to change your composition to take meter readings when the light

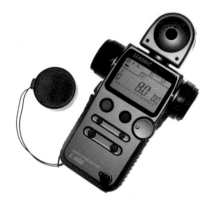

Above **A hand-held reflected light meter can be a useful accessory to carry, even if your camera has a built-in light meter.**

changes, you simply take a new reading independently of the camera and make any necessary adjustments without disturbing your composition.

The best hand-held reflected light meters offer a 1° spot metering facility, which allows you to assess the brightness of very specific parts of the scene. This makes them far more precise than even the best TTL meters in spot mode and provides you with ultimate exposure control in any conditions.

On the downside it is an additional accessory for you to carry and they do not automatically take into account any external factors such as any filters you may be using. This can be particularly apparent when using polarizing filters, where the degree of exposure compensation is less easily calculated than for a fixed filter.

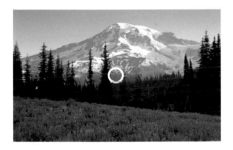

Above **Spot meters provide by far the greatest level of flexibility of any metering system. They can read light levels from very small areas of a scene, giving you complete artistic control over the final image.**

Hand-held incident light meters

Hand-held incident light meters allow you to measure the light falling on a subject (known as incident light or illumination), rather than that reflected from it. An incident light meter has a white plastic dome, or invercone, which averages the total amount of light falling on it before the diffused level of light is measured by the meter's cell. For best results an incident light meter should be placed close to the subject, pointing towards the camera. The advantage of this type of metering is that it isn't confused by contrasting areas of light and dark, as a reflective meter can be,

Left Incident light meters work in a different way from reflected light meters, measuring the amount of light falling on a subject. They are often used by wedding and portrait photographers and are less vulnerable to high-contrast lighting conditions.

and therefore it gives accurate results in most lighting conditions. However, incident meters don't give any selective information, removing a degree of creative control over any exposure.

Below left Incident light meters measure the level of light falling on a subject, not light reflected. They still give a meter reading based on a mid-tone subject. They are best suited to situations where they can be placed close to the subject being metered.

Light source

Incident light

The light meter should be placed between the light source and the subject, in order to take an incident light reading.

Subject

TABLE

8

PROS AND CONS OF DIFFERENT LIGHT METERS

TTL LIGHT METERS

Advantages	Disadvantages
Built into the camera	Are often not as accurate as hand-held meters
Take into account external factors, such as filters and high magnification lenses	Sometimes requires re-framing of the composition
Often come with multiple-function exposure systems	

HAND-HELD REFLECTED LIGHT METERS

Advantages	Disadvantages
Independent of the camera	Additional accessory to carry
Narrow angle of measurement gives greater accuracy	Don't take into account external factors, such as filters used
Complete creative control	Most hand-held meters only offer a single metering mode

HAND-HELD INCIDENT LIGHT METERS

Advantages	Disadvantages
Not influenced by contrasting light and dark areas in a scene	Needs to be positioned close to the subject for best results
Measures light falling on a subject rather than reflecting off it	Lack of selective information

18% grey card

As described earlier, most meters are calibrated to give an accurate reading from a subject with a reflectance value of 18% – a mid-tone subject. When faced with a scene with no mid-tone subjects in it metering from an 18% grey card, in the same light as your subject, will give you a technically accurate exposure value for the scene.

These cards can be bought from most camera stores and are useful. In the field, however, they are often hard to use as practical issues preclude their use for most wildlife and action-related photography. Similarly, with distant subjects such as landscapes, at best a grey card will give you an approximation but it is unlikely you'll be able to position it in an appropriate place where the light is the same for the subject and the card. Having said that, they are very useful if you can get close to your subject and if the level of light throughout the scene is consistent.

18% Grey Card

Left **Grey cards can be bought from most photographic retailers and are a handy tool. They work by being placed in the same light as your subject and a meter reading being taken from their surface. Because they are mid-tone, the resulting meter reading should be accurate.**

Your hand

An alternative to an 18% grey card is to improvise with your own hand, as the palm is approximately one stop brighter than mid-tone. If you take a meter reading from your palm and increase the exposure value by one stop you will have obtained the same result as if you had used an 18% grey card.

Right **If you don't have a grey card or have forgotten to take it with you then metering from the palm of your hand can be a useful substitute.**

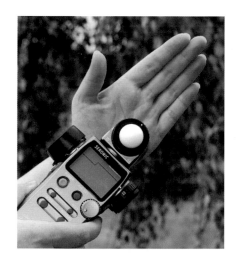

Getting the most from your tools

Most modern photographic equipment is accurate and there is little variation between models. However, to get the best from your equipment there are a number of steps that you should take and issues of which you should be aware.

Calibrating your meter Light meters are calibrated assuming a reflectance value of 18%. Although there is an international standard governing the calibration of meters there is some variation between different models.

To ensure the absolute accuracy of your own light meter you should run a calibration test of your own, following the steps outlined below.

There is a slight problem with this procedure when using film, as film is subject to fluctuations in latitude during manufacture. Therefore, to be precise, you should repeat the process with every new batch of film.

1) Place the card in flat, consistent light conditions. An overcast day is ideal.
2) Using a tripod, if possible, position your camera with a standard lens attached so that the image of the card fills the viewfinder, remembering that most viewfinders do not cover the whole image, so ensure that there is some overlap.
3) Ensure the card is in focus.
4) Set the camera to DX coding or manually set the film speed to the manufacturer's ISO rating. (If using a digital camera set the camera to a commonly used ISO equivalency rating, e.g. 200.) Select manual exposure mode on the camera.
5) Match the camera's exposure settings to the reading given by your meter and take a photograph. This is your base exposure.
6) Keeping the camera in position take eight more pictures at the following settings:
Meter reading +2 stops; +1½; +1; +1/2 –1/2; –1; –1½; –2
7) If you are using film you should then get the images processed. If you are using a digital camera you will be able to review the results immediately on a computer screen.*
8) Line up the Images In order and review them against your grey card. The image that is closest in colour will give you the amount of compensation that you should apply to exposures when metering with the tested light meter. If your meter is correctly calibrated from the factory this should be +/–0.

***Note** Your screen must also be calibrated to show an accurate rendition of your digital images.

Film speed The sensitivity of a film, that is, how quickly it reacts to light is referred to as the film's speed and is indicated by its ISO rating, see page 17. The higher the ISO rating the faster the film reacts to light. Typically, photographers use fast films when needing to shoot in low-light, or when they need to use fast shutter speeds, or often a combination of both. For example, when I'm photographing wildlife I often have to shoot at dawn and twilight when the animals are more active. But, if I'm trying to freeze motion I still need to use a fast shutter speed. Without fast film this is sometimes impossible to achieve.

The faster the film, however, the more grain becomes apparent in the resulting image. Sometimes, grain can produce very atmospheric images, especially in black & white photography. At other times, grain can detract from the quality of the image and slower films are a better choice. Certainly for publication purposes, most picture editors look for images that are devoid of grain, which is the reason Fuji Velvia 50 is one of the preferred choices of professional photographers.

Below **Film speed is related to the amount of light required for the material to react to light. The slower the film the greater the amount of light needed for an image to form.**

Amount of light required in addition to sensitivity of the film or sensor

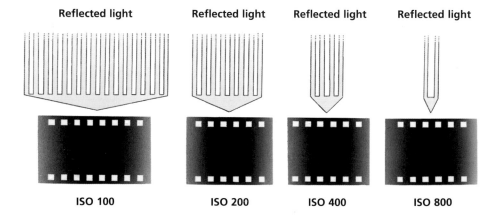

Reflected light	Reflected light	Reflected light	Reflected light
ISO 100	ISO 200	ISO 400	ISO 800

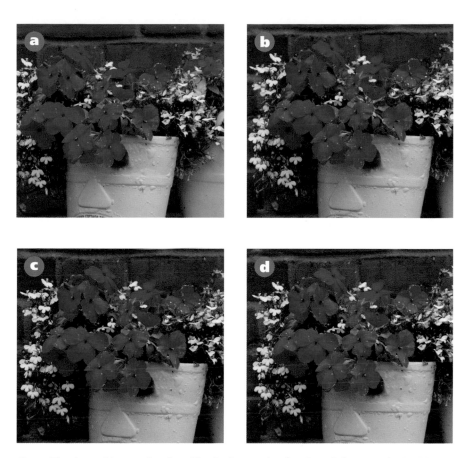

Above **The downside to using fast film is that grain, the size of the crystals used in the film, gets bigger and is more apparent in your photographs. While this can sometimes be used for creative effect is usually best avoided. In digital photography, the same issue arises with digital noise. You can see the progression from a (grainless) to d (grainiest), above.**

Film contrast range Unlike the human eye, which can detect detail with very broad latitude, film can record detail with very limited latitude. A typical negative film, for example, has a contrast range of seven stops (sometimes depicted as a ratio of 128:1). This means that a negative film can record detail in tones from near featureless black to almost pure white. Slide film, on the other hand, is less forgiving and will record detail within a range of only five stops (ratio 32:1).

The film contrast range becomes relevant when you are photographing a scene with many different tones. Any tones that fall outside of the contrast range of the film you are using will lose all detail and appear as black shadows or washed-out highlights.

It is important that you test the contrast range of the films you use in order to improve the quality and faithfulness of your exposures. To measure the contrast range of a film copy the following steps:

1) Place a medium-toned, flat but textured subject in even, consistent lighting.
2) Using the manual exposure mode, meter the subject and expose one frame, to give you your base measurement.
3) Make a series of ten exposures, reducing the exposure setting by 1/2 stop on each occasion.
4) Then, make an additional series of ten exposures, this time increasing the exposure setting by 1/2 stop on each occasion.
5) You will end up with 21 exposed frames. Examine each frame for detail, using the first as your starting point. Count the number of frames either side of this frame in which you can see any detail. The result is the contrast range of the film.

Below **All photosensitive materials have a latitude (the degree to which they show detail in shadows and highlights). None are as good as the human eye so you must learn to see like the camera.**

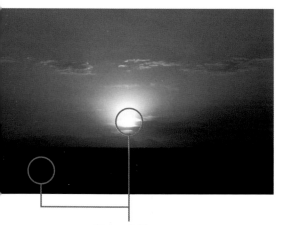

Tones falling outside the film contrast range.

Film colour response Different films respond to colours in different ways depending on the balance between the red, green and blue layers that form the emulsion. An equal balance will produce a natural colour response. That is, the subject will appear much the same on film as it is does to the human eye. Some films are purposefully balanced towards a particular colour, however. Therefore, to be able to pre-visualize how the colours in a particular scene will appear on film it is worth testing the film for colour response. Copy the following steps:

1) Acquire a set of similar objects of different colours ensuring they include the colours red, green and blue. (Perhaps a set of children's building blocks.)
2) Place them on an even surface under flat, consistent lighting. Include a grey card for reference.
3) Metering from the grey card make an exposure.
4) Examine the results to see how the film responds to the colours.
5) To see how the film responds to colours at different levels of brightness repeat the above process at different exposures.

DIGITAL SENSORS

Digital cameras use sensors as the light-sensitive material in place of film. In many ways digital capture is more flexible than film and allows you to alter the ISO equivalency, the contrast range and colour response for each frame. You no longer need to carry different films for different occasions, you simply make the adjustments as you shoot.

It is still important, however, that you test your sensor at its standard settings in order to give you a set of base values for noise (equivalent to grain in film), contrast range and colour response. To measure each of these areas simply repeat the tests detailed above for film.

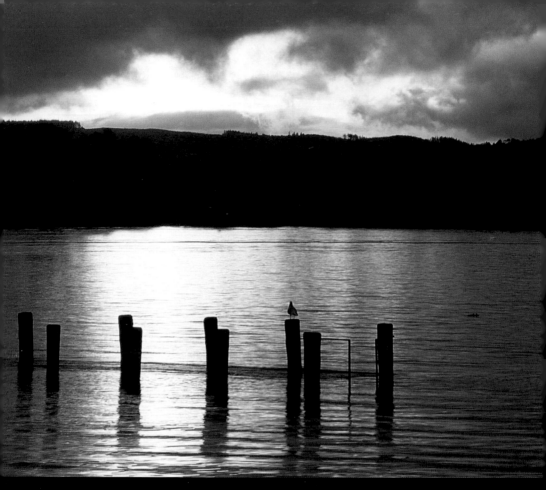

Calculating

4

exposure in six simple steps

Already you will have noticed that achieving faithful exposures takes more than pointing your light meter – in-camera or hand-held – at a scene and accepting what it tells you as the truth, the whole truth and nothing but

In the previous two chapters I have touched on the limitations of the light meter and remarked on how your choice of film, lens aperture and shutter speed selection, ISO (and ISO equivalency) rating and personal vision directly affect the appearance of the photographs you make. Getting to grips with these elementary principles of exposure is central to gaining an appreciation of the exposure equation and your ability to make informed decisions when selecting exposure values.

Over the following two chapters I am going to explore in greater detail the process of calculating exposure values, compensating for the limitations of the light meter, applying your creative interpretation and managing extreme conditions.

Below **Exposing for the light in this kind of scene can be a real nightmare. Get it right, however, and you'll be repaid with images like this.**

35mm camera, 24mm lens, Fuji Velvia, 1/250sec at f/22

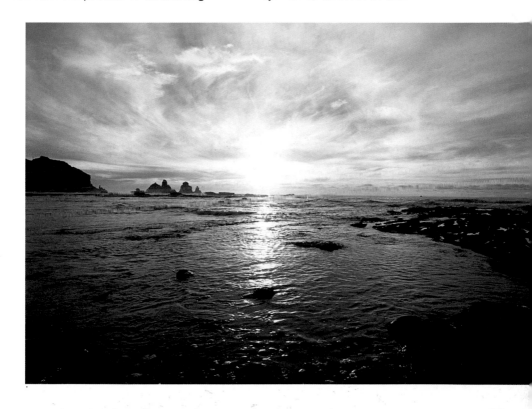

Setting film speed / ISO equivalency

The first step in the process of calculating exposure is setting your desired film speed or ISO equivalency (in digital capture). If you are using a 35mm or roll film camera then you are limited to setting an ISO rating for the entire film. You are also going to be somewhat tied to the ISO rating of the film in use. However, it is possible to change the nominal ISO rating of the film in use by altering the ISO setting on the camera – if your camera allows manual adjustment and doesn't just work on DX coding. This process is known as up-rating (pushing) or down-rating (pulling) film.

Below **Low-light photography is an example of where you may want to push film in order to gain additional stops of light. Here I up-rated or 'pushed' Fuji Velvia from its factory rating of ISO 50 to ISO 100.**

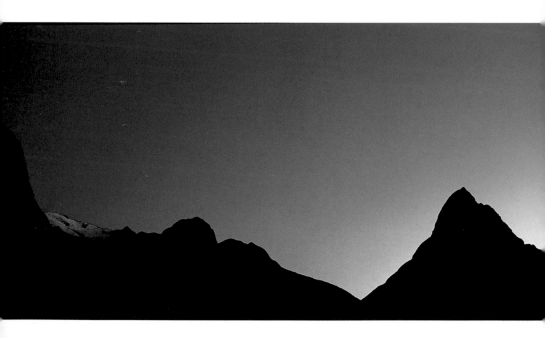

PUSH PROCESSING

If you find yourself needing extra speed then rather than switching to a faster film you can rate a slower film at a higher ISO rating. This process is referred to as pushing or up-rating film, and effectively gives you an additional one or two stops of light to work with. (Pushing by more than two stops is not really recommended.) There are a number of reasons you may want to push a film but usually it is because light levels are too low to achieve the desired combination of lens aperture/shutter speed for the exposure you want. Also, some films react particularly well to up-rating, so much so that that an ISO 100 film rated at 200 can give better results than a true ISO 200 film. Of course you can only apply this technique to the entire roll of film and it's essential that you tell the processing lab what you've done, otherwise you'll end up with a set of underexposed pictures.

When you up-rate (push) a film you are effectively asking the camera to act as if the film was more sensitive to light, and, effectively, it becomes a faster film. You may, for example, change the rating of an ISO 100 film to ISO 200 by setting the camera's film speed setting to ISO 200. When the camera's meter takes a reading it will assume this revised rating and give an exposure value accordingly. The purpose behind pushing film is to gain additional stops of shutter speed or aperture when conditions or circumstances dictate.

Some films react better to being pushed than others and it is never wise to push a film beyond two stops. Before pushing a film it is

recommended that you refer to the manufacturer's technical guide.

When conditions are very bright you may decide to down-rate (pull) the film, decreasing its nominal ISO rating. The process for pulling film is opposite to that of pushing it.

Pushing film is a far more common practice than pulling it. In either case it is important that you tell the processing house what you've done so they process the film accordingly.

Digital capture has made changing the sensitivity of the recording material far more flexible and it is now possible, with some digital cameras, to change the ISO equivalency rating for every shot. As with film, however, remember that the faster the ISO equivalency you set the more 'noise' will appear in the final image.

up-rated film
+1 stop

Above **Mark any up-rated or down-rated film canister with an appropriate label so that the processor knows what you've done and will compensate.**

Below **Film can either be 'pushed' (up-rated) to overexpose or 'pulled' (down-rated) to underexpose. This is then compensated for during the processing stage.**

ISO rating

| 50 | 100 | 200 |

down-rating 'pulling' up-rating 'pushing'

◯◯◯◯④◯◯◯◯

Deciding the area of the scene to meter

Because all light meters give an exposure value based on a mid-tone you should first look for an area of the scene that is mid-toned and in the same light as the main subject, from which you can take a base reading. Assuming all other tones in the scene are within the contrast range of the film or sensor then they will all appear in the final image as they do to the naked eye.

If no appropriate mid-toned areas exist within the scene then decide on which area of the scene is the primary subject and meter from that subject. Then apply the appropriate exposure compensation factor, as described on page 72.

Below **Here, the red letterbox is a middle-tone colour, although the white wall is around 2 stops brighter than mid-tone. By using a spot meter to read the brightness of the letterbox and setting the exposure settings accordingly, a faithful exposure has been achieved, without the need for exposure compensation.**

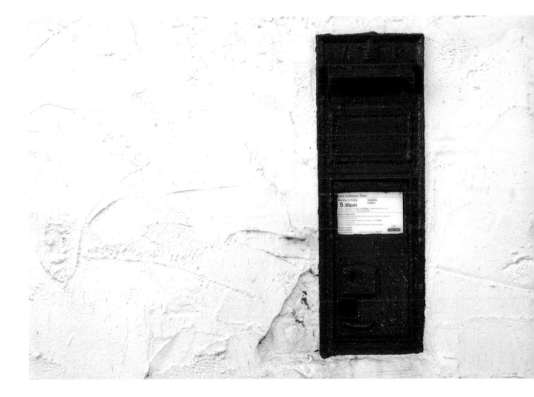

Taking a meter reading

You would think that this was the easy part, simply point the meter at your subject and 'hey presto', you've got your meter reading. Unfortunately, it's a little more involved than that. How you obtain your meter reading to give a technically accurate result depends on many things, including the type of meter you're using, the exposure mode used by that meter, the subject-to-camera distance, the angle of light incidence and the form of the subject. So, now that I've complicated matters, how do you take a meter reading? To answer that question, let's first consider the basics. Then I'll cover the complicating issues.

TTL meters

Most of you will be using a built-in TTL meter and so I'll start here. The main advantage of the TTL meter is that it measures the amount of light actually entering the lens and, by default therefore, the amount of light reaching the film. A TTL meter will automatically take into account factors such as filters used and lens magnification. However, modern TTL meters come with multiple metering modes and each one needs handling differently.

Metering with TTL metering set to multi-segment metering

mode This is the most common form of light meter and takes an average of the entire scene. They are most effective when the subject brightness range of the scene is within the contrast range of the film, and the scene has a predominance of medium tones.

The technique here is much aligned to point-and-shoot. Given the above conditions the meter will give a technically accurate meter reading that you can then interpret as you wish. Be aware, however, that the main disadvantage of this type of meter is its inability to provide any specific information about individual areas of the scene. Because of this, you are limited in the amount of creative control you can assert over the camera.

Opposite **The limitation of TTL-average metering is the lack of information provided about specific areas of a scene. As such subjects with a high SBR, such as a zebra, can cause this type of system to give inaccurate results.**

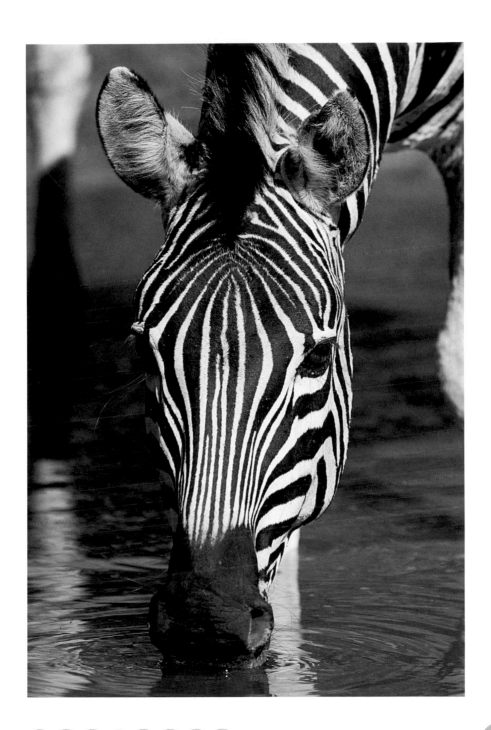

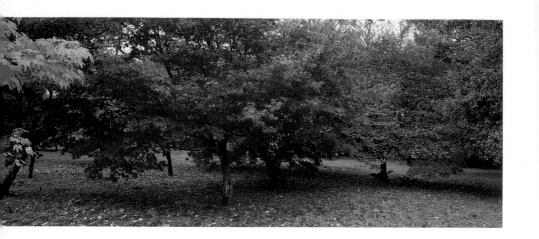

Above **Scenes where the tonality is even and contrast is relatively low are ideal situations in which to use your camera's built-in TTL-average multi-segment metering function.**

Below **The lighting in this scene, combined with the even tones of the foliage mean that this is a good example of when to use TTL multi-segment metering.**

Metering with TTL metering set to centre-weighted metering mode The centre-weighted setting is ideal for portraits, where the main subject fills around 75% of the frame, and where the subject brightness range (SBR) between foreground and background is within the film or sensor's contrast range. The technique for metering a scene using centre-weighted metering depends on the position of the subject, that is, whether the subject is central to the image space or off-centre.

When the main subject is central to the image space frame the picture so that the main subject fills the metering circle depicted in the viewfinder and then take your meter reading. If the subject is too far away to fill the centre-metering circle then change to a longer focal length lens to meter the subject, switching back to your preferred lens before shooting. This is necessary because subject-to-camera distance affects exposure calculation. If you have no appropriate lens available then move nearer to the subject, take the meter reading and bracket by 1/3 stop either side.

If the subject is off-centre then set the camera to the manual setting and centre the subject in the viewfinder. Then follow the process outlined above. Once you have determined your exposure and dialled in the appropriate settings, reframe the subject to its original position and take the picture.

Right and below right
Because the main subject of the image was off-centre, I first took a meter reading from the body of the ostrich (right). **Then, keeping the meter reading, I recomposed the image to suit my chosen composition** (below right).

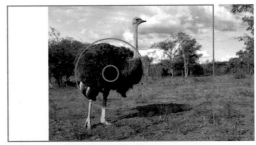

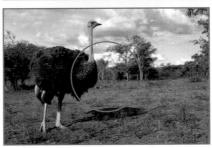

Metering with TTL metering set to spot metering mode Spot metering provides you with the ultimate control over exposure. A TTL spot meter will typically cover an angle of view of no more than 3°–5°. With a spot meter it is possible to measure specific parts of a scene to ascertain the true subject brightness range. The technique for spot metering is to point the metering sensor directly towards the area of the scene you want to meter. By measuring all the different tones within a scene in this way you can accurately assess the subject brightness range of the entire scene.

Hand-held meters

Hand-held meters usually offer two types of metering: reflected light metering (similar to TTL metering) and incident light metering. When operated in reflected light mode they become highly accurate spot meters, often with an angle of view of 1°. In incident light mode they measure the amount of light falling on a subject, as opposed to reflecting off a subject. The techniques for metering with the different modes are quite diverse.

Below **With a spot meter you can accurately assess the full SBR of a scene before calculating your exposure.**

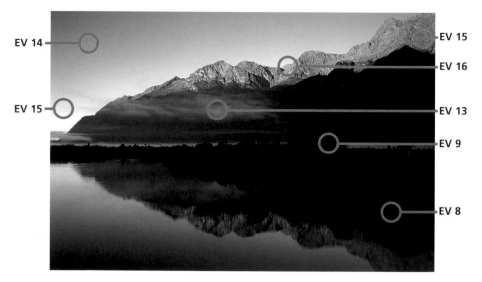

EV 14 — EV 15
EV 16
EV 15 — EV 13
EV 9
EV 8

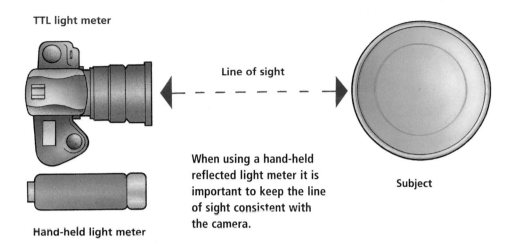

TTL light meter

Line of sight

When using a hand-held reflected light meter it is important to keep the line of sight consistent with the camera.

Hand-held light meter

Subject

Metering with a hand-held meter in reflected light spot metering mode The principles for metering in spot metering mode with a hand-held meter are the same as for TTL metering in spot metering mode. It is important to keep the line of sight close to the camera, as the further you stray from this point the less accurate the reading will be.

The main difference is the areas covered by the hand-held meter compared to a TTL meter. Because it has such a narrow angle of view it is possible to isolate extremely small areas of the overall scene, which increases the accuracy of the meter reading. Because of this it is important to make sure that you take your meter reading from the correct area.

When using a hand-held meter it is important that you remember to take into account any external factors not automatically covered by the meter, for example, filters or high magnification lenses and accessories, such as extension tubes.

Metering with a hand-held meter in incident light metering mode Incident light meters differ from reflected light meters in that they measure the light falling on a subject rather than the light reflecting back off the subject. The main advantage of this type of metering is that, unlike reflected light meters, light and dark areas within the scene do not influence the exposure values. Therefore, if you want your images to appear as they do to the naked eye you can

TTL light meter

3°–5°

Angle of view

Left Hand-held reflected light meters often have a spot metering facility with a narrower angle of view (often 1°) than even the best in-built TTL meter.

Hand-held light meter

1°

Angle of view

Left Because of the way in which they meter, incident light meters are most effective when they are used close to the subject.

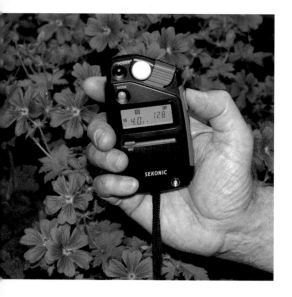

achieve highly accurate results. On the flip side, the main disadvantage of incident light meters is that, because they don't measure the subject brightness range, they provide little information with which you can gain creative control over the resulting photograph.

The technique for metering with this type of meter depends on the subject you are photographing. If you are able to approach the subject – say a person or a pet – then place the meter close to the subject with the invercone pointing towards the camera lens and take the meter reading.

If the subject is further away or is unapproachable – such as a landscape or a wild animal – then hold the meter above your head with the dome pointing away from the camera and take the reading.

With this second approach there are some other limitations you need to bear in mind. First of all, this technique tends to fail on bright sunny days when the intensity of the light can cause the meter to give a reading that will underexpose your picture. Also, on very stormy days, when only small patches of the landscape are illuminated, the meter won't be able to read the light.

As with the hand-held reflected light meter you will still need to take into account any external factors affecting your exposures (filters, extension tubes, etc.)

Remember, too, that incident light meters are also calibrated to give a medium-tone light reading and the same compensation rules apply as for reflected light meters.

Below **On days with bright sunshine the intensity of the light can cause an incident meter to recommend shorter shutter speeds or narrower apertures than are appropriate, causing underexposure.**

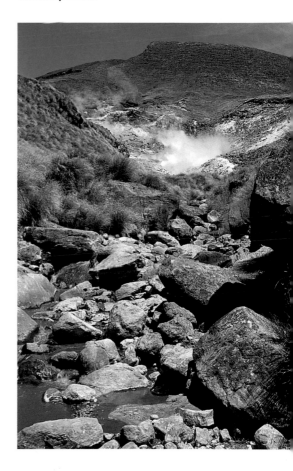

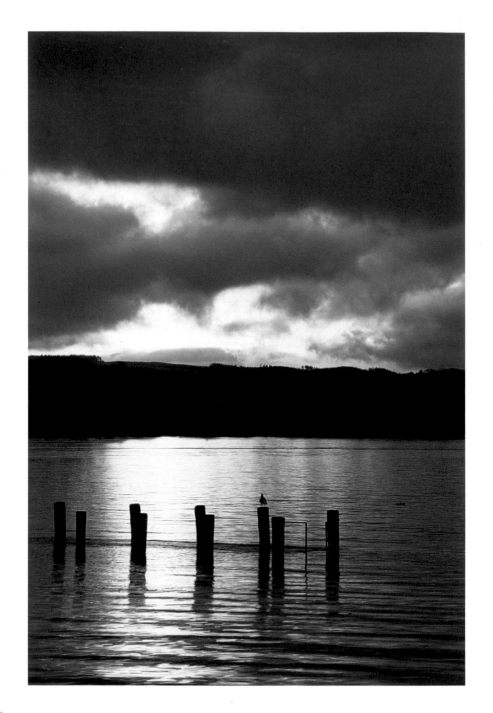

Opposite **The stormy clouds combined with the effect of the sunlight makes for complex lighting conditions. The patchy quality of the light means only small sections of the landscape are illuminated. In situations such as these incident meters are less effective, and will not guarantee correct exposures.**

The angle of incidence

The main factor affecting meter readings, above and beyond those already discussed, is the angle between the light source and the position of the subject in relation to the camera. The brightness of a surface will alter depending on the direction you view it from in relation to the light source. To ensure a technically accurate meter reading it is important to keep the light meter as close to the line of sight between the camera and the subject. Of course, a TTL meter has the most accurate line of sight so long as the meter reading and the photograph are taken from the same spot. The diagram below illustrates this point.

Below **The angle of incidence may affect your meter reading and it is necessary for accurate readings to keep the line of sight between meter and camera consistent.**

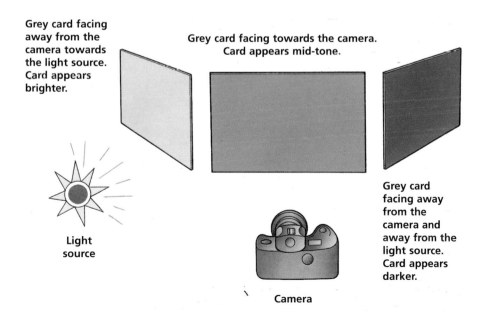

Grey card facing away from the camera towards the light source. Card appears brighter.

Grey card facing towards the camera. Card appears mid-tone.

Grey card facing away from the camera and away from the light source. Card appears darker.

Light source

Camera

Interpreting meter readings

As I discussed earlier, all light meters are calibrated to give an exposure value for a mid-tone subject – one that reflects 18% of light.

When metering a mid-tone subject your meter should give you a technically accurate exposure value. The problems start when the subject you are metering is darker, or lighter than mid-tone. Your meter assumes all subjects are a mid-tone, whatever their colour. But, the likelihood is that you will want subjects that are lighter than mid-tone to appear lighter than mid-tone; and subjects that are darker than mid-tone to appear darker than mid-tone. For example, you normally want snow to appear white, rather than grey. Your meter, however, will tell you only how to expose white snow as a mid-tone. Similarly, you want a black cat to appear black. Again, your meter will provide you with an exposure value

that indicates mid-tone – medium grey. While exposure values are often referred to in terms of grey tones the same rule applies for any colour. For example, imagine you were photographing a blue sky in the early morning. A direct meter reading would give you an exposure value equivalent to medium blue – a tone of blue you would expect to see at noon. For an example of this problem try test A, opposite; and for a solution try test B.

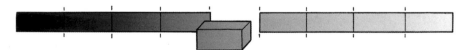

A meter reading of a blue sky in early morning would provide an exposure value equivalent to medium blue.

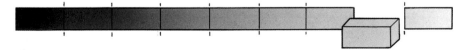

A more accurate tone for early morning blue sky, however, is lighter than medium blue. Opening up the exposure by, in this case, between 1 and 1½ stops would give you the tone that more closely matches the colour of the sky.

On an overcast, dry day place three pieces of card on the ground – one white, one black and one medium grey. Set the camera's meter to autoexposure and photograph each piece of card separately, ensuring they fill the entire frame. When you review the results you will see that each photograph appears the same in tone – medium grey – as shown here.

White	Black	Grey

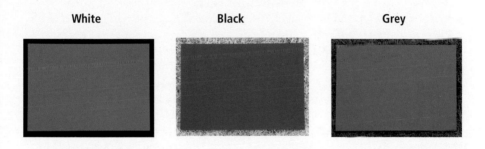

Now replicate the previous exposure test, this time adding two stops of light from the meter's indicated exposure value when photographing the white card and subtracting two stops of light from the meter's indicated exposure value when photographing the black card. When you view the results you will see that the colour of each image is much closer to its true colour.

White	Black	Grey

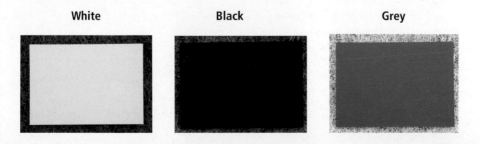

Exposure compensation

So, when you take a meter reading you must ask yourself the question, 'Is the subject I am metering middle tone, lighter than middle tone or darker than middle tone?' If the subject is middle tone then you need make no adjustment to the exposure value given by the meter. However, if the subject is lighter than middle tone then you need to add light (open up the exposure) and if the subject is darker than middle tone then you need to subtract light (stop down the exposure). Remember that the meter effectively underexposes lighter-than-middle tones in order to make them darker and overexposes darker-than-middle tones to make them lighter.

The next question you will be asking is, 'How much compensation should I apply for different subjects?' The chart below can be used as a guide.

You may have noticed that throughout this section I have referred to everything in terms of a grey scale – as illustrated above. This is because most light meters, with only a very few exceptions, 'see' everything as a grey scale – they do not recognize colours. This makes life a little complicated for you as the photographer because you see everything in colour. Therefore, in order to interpret the tones accurately in any scene, you must be able to match colour tones to the grey scale. To help you along the way I have provided some guidance in the chart below. Remember that these figures are approximations and should always be tested using your own kit.

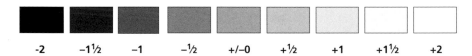

| -2 | −1½ | −1 | −½ | +/−0 | +½ | +1 | +1½ | +2 |

Above **Cameras see everything in terms of a grey scale, as shown here. Levels of exposure compensation for different tones are indicated for guidance.**

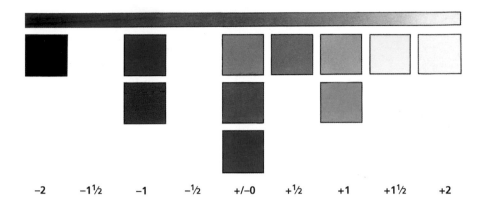

| −2 | −1½ | −1 | −½ | +/−0 | +½ | +1 | +1½ | +2 |

Above **Different colours reflect different levels of light and in order to render the colours correctly in the final exposure** you must compensate accordingly. The values given here can be used as an exposure guide.

Applying exposure settings

Now that you have identified your required exposure settings the next step in the process is deciding which combination of settings to use. I have already identified lens aperture and shutter speed as the two main tools for managing exposure. What you have to decide is which of the two gets priority.

Lens aperture One of the decisions you have to make when taking a photograph is what the 'story' is. For example, are you trying to give the subject a sense of place? Or are you trying to emphasise and to isolate a part of a scene? How a viewer 'reads' the pictures you make should be determined by you, not by the camera, and one of the mechanisms you have available to take control over the creative aspects of image making is lens aperture. Lens aperture affects the amount of depth of field you have to work with and depth of field influences the way we perceive a scene or subject. In the example on page 86, the larger image has used a very shallow depth of field (wide aperture) to place the emphasis on the animal and its behaviour. It is impossible to tell where the leopard is as the photograph provides no information about a sense of place. In the smaller image, however, I have used a narrow aperture to increase depth of field, making more of the overall scene sharp, giving more information about the animal's habitat.

Calculating exposure in six simple steps

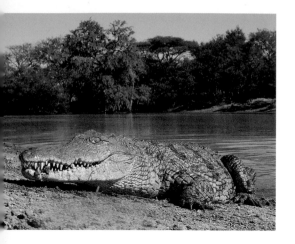

Left **In this image, a large depth of field makes the animal's surroundings more obvious. This is useful when you want to place a subject in a wider context. Showing an animal in its natural habitat can add an extra level of interest for the viewer and also adds variety to your portfolio of images.**

Below **By selecting a wide aperture, depth of field is greatly reduced, which can help to disguise an unsightly background. In this case the wire mesh of the enclosure is no longer visible as the depth of field is too shallow to render anything other than the leopard's face sharp on film.**

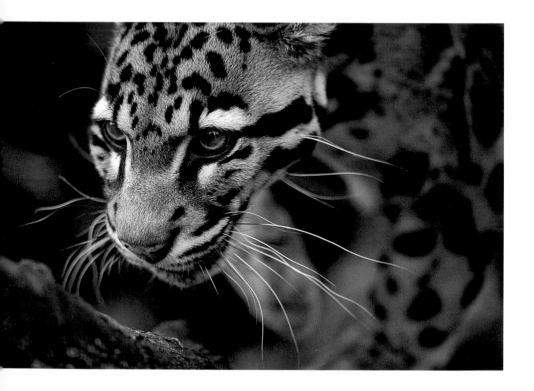

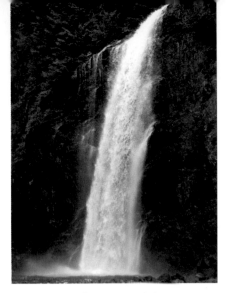

DEPTH OF FIELD

As well as aperture, depth of field is also affected by focal length and distance to subject. For the exact depth of field you need to refer to depth-of-field charts. Some cameras have depth of field preview that allows you to see the available depth of field in the viewfinder.

Shutter speed The other creative decision you have to make is how you represent motion in your pictures, and motion is controlled via shutter speed. A fast shutter speed will freeze the action of motion giving a more static appearance to the subject. Using a slow shutter speed will have the opposite effect, blurring the edges of the subject giving a sense of movement. Look at the two sample images, right, of a waterfall and note how changing the shutter speed affects the way the motion of the water is recorded.

Above **A fast shutter speed (here 1/100sec) will freeze motion, this will show subject detail although the image may look static.**

Below **A slow shutter speed (here 1/10sec) will blur motion. This can help to create a greater sense of visual energy in the final image, and convey how a subject moves.**

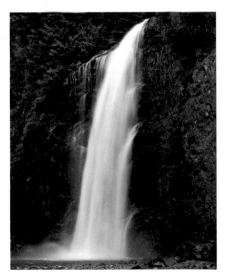

CAMERA SHAKE

Shutter speed may also take priority if you are hand-holding the camera. In this instance a fast shutter speed will help to minimize camera shake.

Bracketing

Despite your best efforts it is sometimes impossible to calculate exposure values faithfully. Many factors can cause you to misjudge an exposure, such as very bright sunlight reflecting off shiny surfaces (e.g. water, sand and glass), constantly changing light conditions, and subtle variations in a subject's tonality. Consider, too, that film manufacturers and processing laboratories operate to tolerance levels that could make a difference of up to a 1/2 stop in your exposures.

For this reason it is often advisable to bracket your exposures: that is, take more than one photograph of the same scene at varying exposure values above and below your initial exposure setting. Typically, the variance should be around a 1/3–1/2 stop. On rare occasions you may want to go as far as +/–1 stop.

DIGITAL CAPTURE – BRACKETING

The advent of digital capture has made bracketing less essential through instant replay of images. However, even with digital technology bracketing has a role to play. Consider a scene that involves a fast-moving subject, such as a racing car or a cheetah chasing an antelope. On these occasions time will not allow for you to check the exposure in the screen and then go back to try the shot again if the resulting image isn't what you had planned. Also, the digital screen on the camera is not always a true reflection of the actual brightness value of the image.

−1/2 stop

given meter reading

+1/2 stop

What to
do when...

5

Of course, if exposure were as simple as all that then
there would be little need for a book like this. In reality, the
interaction between light and subject can often become quite
complex. While the ability to obtain faithful exposures under normal
conditions will improve the consistency of your image making, your ability to
handle extreme conditions will ensure that you are able to take advantage of
all the photo opportunities that come your way.

Photographing in bright sunlight

In extremely bright conditions on a clear day lighter-than- and darker-than-middle-tone subjects can easily fool your camera's meter. Any exposure compensation you apply will be ineffective if the original meter reading was off the mark. The solution to this problem is to use the 'sunny f/16' rule. Despite the millions of dollars invested by the camera manufacturers in designing the ultimate light meter, sometimes the simple solutions are the best solutions. The 'sunny f/16' rule works by setting your lens aperture at f/16 and your shutter speed at the setting closest to that of the ISO rating of the film you're using. For example, if you're using Fuji Provia 100F, then your exposure setting using the 'sunny f/16' rule would be f/16 at 1/100sec (or 1/125sec if your camera doesn't allow 1/3 stop adjustments). Once you have this base setting you can

Right **The following four images were all taken using the 'sunny f/16' rule. Work each exposure setting back to f/16 and all the shutter speeds will equal 1/50sec – the ISO rating of Fuji Velvia is 50. Stirling Falls, Milford Sound, New Zealand.**

35mm panoramic camera, 45mm lens, Fuji Velvia, 1/200sec at f/8

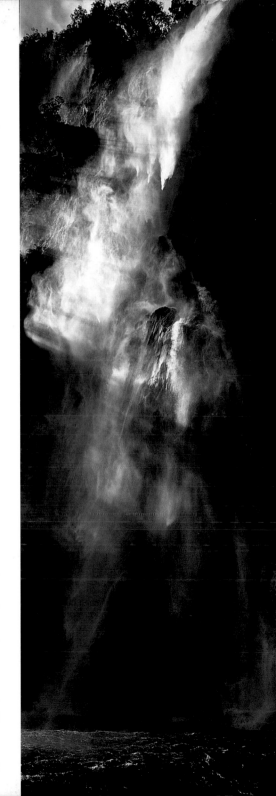

then use any equivalent combination of settings. In the above example, for instance, you could also use 1/200sec (1/250sec) at f/11 or 1/50sec (1/60sec) at f/22. If you don't believe me, try it! The four images on pages 91–3 were taken using that calculation.

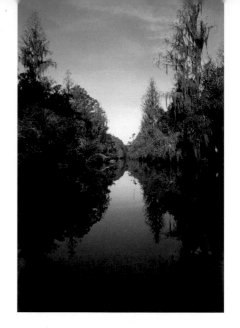

Below **Lindisfarne Castle, Lindisfarne, Northumberland, England.**

35mm camera, 24mm lens, Fuji Velvia, 1/12sec at f/32

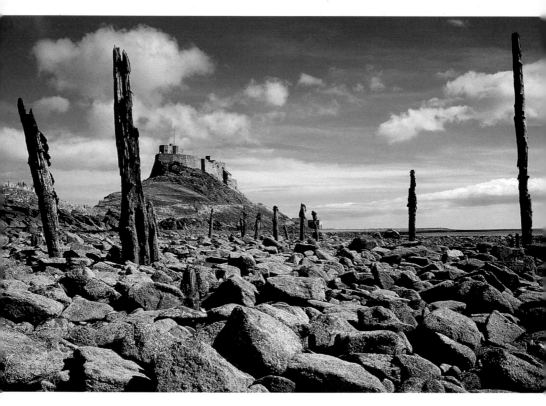

Opposite top **Okefenokee National Wildlife Refuge, Georgia, USA.**

35mm camera, 50mm lens, Fuji Velvia, 1/50sec at f/16

Below **Tongariro Pass, Tongariro National Park, New Zealand.**

35mm camera, 28mm lens, Fuji Velvia, 1/25sec at f/22

Photographing white subjects in bright conditions

One time when the 'sunny f/16' rule is less effective is when you are photographing white subjects under very bright conditions, when the subject fills a large portion of the picture frame. Under these circumstances using the f/16 setting would result in losing detail in the highlights – something best avoided if at all possible. You would encounter a similar problem when including highly reflective, shiny surfaces such as sand, snow or water.

A variation of the 'sunny f/16' rule is the 'sunny f/22' rule. It works in exactly the same way except your base lens aperture setting is f/22. Reducing the level of light reaching the film by half will darken the highlight areas of the image and add detail. As with the 'sunny f/16' rule, once you have determined the correct shutter speed at f/22 you can use any equivalent combination of settings for your final exposure.

Below **The 'sunny f/16' often fails with a white subject on a bright day. This image of the Franz Joseph Glacier on New Zealand's South Island was taken using the alternative 'sunny f/22' rule.**

35mm camera, 200mm lens, Fuji Provia 100F, 1/400sec at f/11

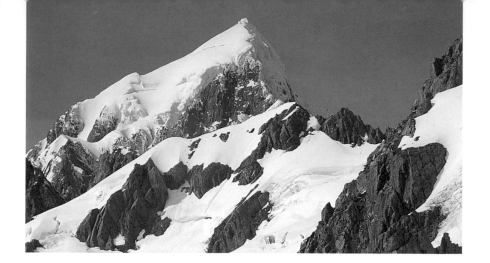

The two images on this page are further examples of where to use the 'sunny f/22' rule to reproduce white faithfully.

Above **Mount Cook Range, South Island, New Zealand.**

35mm camera, 400mm lens, Fuji Velvia, 1/200sec at f/11

Right **White heron, Mkuzi National Park, Kwa-Zulu Natal, South Africa.**

35mm camera, 800mm lens, Fuji Provia 100F, 1/800sec at f/8

Photographing backlit subjects

You probably remember the age-old advice, always photograph with the sun behind you. Fortunately, the photographic art has moved on since that phrase was coined and light is now used far more creatively. One of the most difficult lighting situations to meter for is shooting into the light, where your subject is backlit. The light coming from behind the subject fools the meter and you end up with an underexposed image, where the surface facing the camera – that is, the surface you're photographing – loses all detail.

Getting close to the subject so that it fills the frame will overcome the problem but this is not always possible. The best solution to this

Above **Cropping right in on a backlit subject makes exposure simpler. Here I wanted to accentuate the colour of the Japanese maple leaves, so I exposed for the red and closed down one stop to help saturate the colours and to account for the bright sunlight shining through.**

35mm camera, 120mm lens, Fuji Velvia, 1/30sec at f/5.6

dilemma is to use a spot meter and to meter only the surface area facing you. Because the spot meter has a very narrow angle of view the bright backlighting won't influence it. If your camera has no spot meter you can improvise by attaching a long telephoto lens and using centre-weighted metering instead.

If all else fails, backlighting is one condition where the hand-held incident light meter is worth its weight in gold. Hold the meter above your head and in front of you with the invercone facing towards the camera. The meter will then read the light falling on the surface in shadow.

WARNING
Never look directly into the sun, either with the naked eye or through a camera.

Below **Shooting up towards the sun, I took a spot meter reading of the underside of these giant fern trees, which were a middle-tone green.**

35mm camera, 28mm lens, Fuji Velvia, 1/25sec at f/8

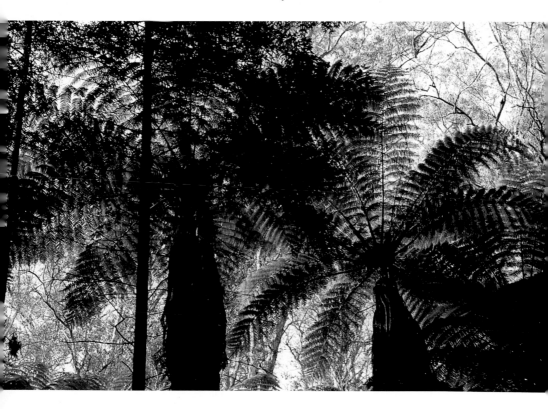

Photographing silhouettes

Sometimes when photographing into the light you purposely want the subject to be underexposed in order to create a silhouette. Silhouettes are very powerful images and demonstrate my principle that there is no such thing as correct exposure. When creating a silhouette you should do the complete opposite to what I've just advised for photographing backlit subjects. What you are trying to achieve is the removal of any detail on the surface in shadow. Take a meter reading from an area behind the subject but excluding the light source itself. Then take a spot meter reading of the subject. If the difference between the two readings is greater than the contrast range of the film or sensor then the shadow will show no detail and be rendered, in the final image, as a silhouette.

Below **Silhouettes are both effective and easily achieved. For this picture of a lone oak tree, I took a meter reading from the sky just above the hedge on the right and opened up one stop.**

35mm camera, 300mm lens, Fuji Velvia, 1 sec at f/11

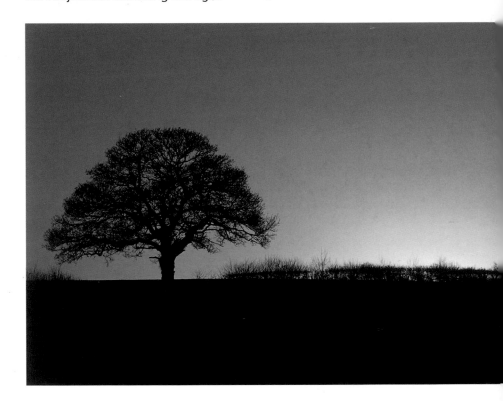

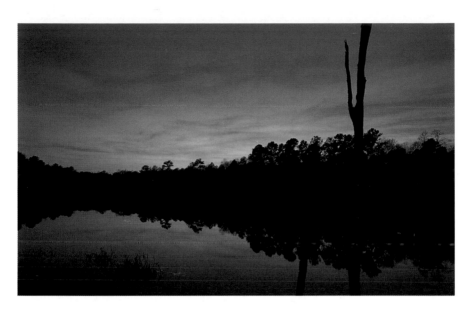

For these two images I used the same technique, taking a reading from the light part of the sky and opening up one stop.

Above *35mm camera, 24mm lens, Fuji Velvia, 1 sec at f/22*

Below *35mm panoramic camera, 45mm lens, Fuji Velvia, 1/2sec at f/8*

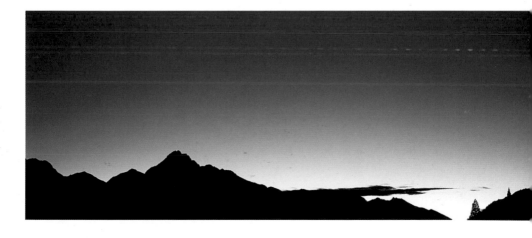

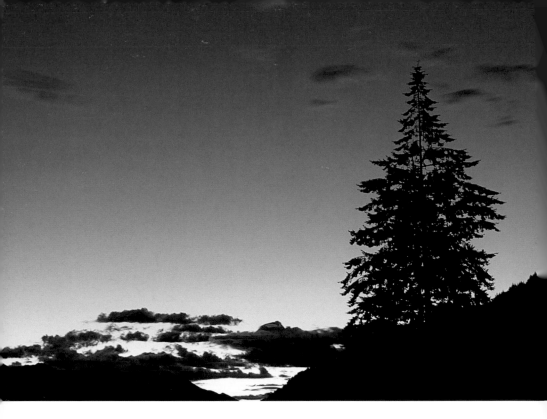

Above **The hours in between sunset and night can produce some very evocative images.**

35mm camera, 300mm lens, Fuji Velvia, 1 sec at f/5.6

Photographing in low light

When photographing in low light the same exposure rules apply as for any other lighting conditions. The problem that you are likely to encounter is when the light gets so low it is beyond the sensitivity range of the meter. There are two possible solutions and, again, the hand-held incident light meter may come to your rescue.

The dome on an incident light meter removes around 80% of the light falling on it. Remove it and this 'lost' light is allowed to reach the metering cell. This may be enough to get the meter back

above its sensitivity threshold. If it is then take an incident light reading as normal (described on page 77) and then set 1/5 of the indicated exposure as your medium-tone setting. (The 1/5 calculation replicates the use of the now removed dome.)

The other alternative is to use your experience and a bit of guesswork. If the light illuminating your subject is too low to meter look for a brighter area of the scene and meter from that, most likely using a spot meter. Then, estimate the difference between the brightness value and adjust the meter reading accordingly.

Using very slow shutter speeds

There are numerous circumstances that will dictate you working at long shutter speeds (greater than one second). Low light is one example. Using slow film or low ISO equivalency on a digital SLR, or shooting at minimum apertures are others.

The law of reciprocity is that a change in one exposure setting can be compensated for by an equal and opposite change in another. However, due to the way film emulsion reacts to long-time exposures this law no longer applies once your shutter speed exceeds one second. In a nutshell, film sensitivity decreases the longer it is exposed to light. So, for example, if you were working with an exposure setting of f/11 at two seconds and decided to alter the lens aperture to f/16 to gain additional depth of field, normally you would simply reduce the shutter speed to four seconds to compensate. However, if you did just that the resulting image may be underexposed. This reaction is referred to as reciprocity law failure and must be compensated for when shooting at slow shutter speeds. The table on page 104 indicates the degree of compensation required for some of the most popular film types.

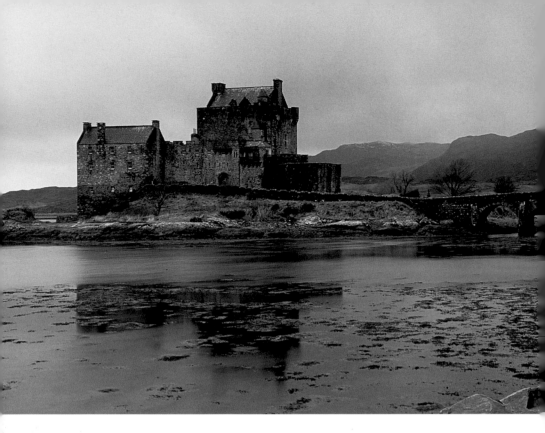

Above **With exposures longer than one second you fall foul of the law of reciprocity failure. To capture Eilean Donan Castle in Scotland I increased my original setting of 4 sec at f/22 by a 1/2 stop to 6 sec at f/22 in order to take account of the decreasing sensitivity of the film.**

Opposite below **In high-contrast situations like this it is best to experiment and see what works for you.**

35mm panoramic camera, 90mm lens, Fuji Provia 100F, 15 sec at f/8

Left **Photographing a full moon on a clear night I have found an exposure setting of 1/30sec at f/11 on ISO 100 film usually works well.**

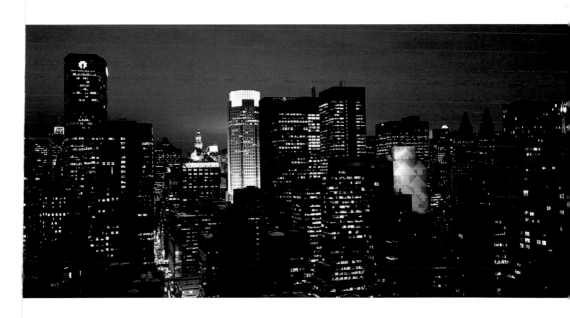

Photographing high-contrast scenes

If everything in photography worked on the law of averages then our lives would be much simpler. Unfortunately, life's not like that and we are often presented with scenes that are far from average. The human eye is an exceptional tool and we can distinguish detail in light and dark objects with a great deal of latitude. Photographic film and digital sensors, on the other hand, have limited latitude and, when deciding how to expose for a certain scene, you must be aware of these limitations.

The range between the subject's darkest and lightest areas is known as the subject brightness range (SBR). When calculating exposure values you must first determine the degree of variation. To help in this exercise we can use a modification of the zone system, devised by the great American photographic pioneer, Ansel Adams.

The grey scale, reproduced below, is a graphic representation of how the real world appears in grey tones. When inventing the zone system, Adams divided the scale into nine distinct and equal segments. (This was later extended to eleven zones although, for the purpose of this book, I shall concentrate on the original nine, the eleven-zone system being recommended only for large-format photography.)

Below **To help relate the grey scale to exposure calculation each segment has an identifying number, 1 being pure black and 9 being pure white. Starting from zone 1, the centre of each segment is exactly twice as bright as the previous segment and equals a one-stop difference in exposure value. The middle segment – zone 5 – is medium grey and is the equivalent of the 18% grey that all light meters are calibrated to record.**

THE ZONE SYSTEM

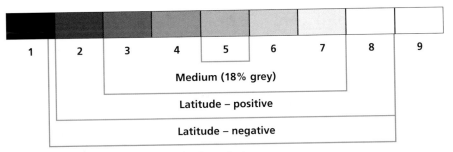

Medium (18% grey)

Latitude – positive

Latitude – negative

Latitude – photo-sensor

So how does this work in practice? Using the grey scale, for each of the tones visible in the scene you are photographing, you can identify which zone they fall into. Once you have applied a zone for each part of the scene you will have identified the SBR. To illustrate this, look at the photograph, right.

I have applied a zone value to each part of the scene, where the tone varies in brightness. You can now see that the darkest part of the scene falls into zone 2 and the brightest part of the scene falls into zone 9. This gives me a SBR of eight stops – far in excess of the latitude of slide film and even outside that of print film and digital CCD. What this exercise allows me to do is pre-visualize the final image and to make the necessary adjustments in-camera to achieve an SBR within the latitude of the film I am using or, as in this case, to make a decision on whether to expose for the highlights or shadow areas.

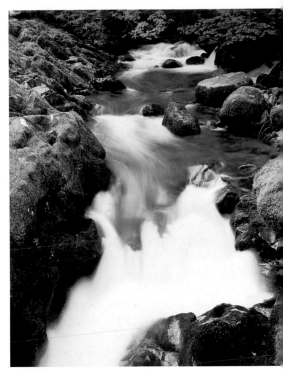

Right **Compare the image above with this overlay. The brightness range in this scene is around eight stops, three stops greater than the latitude of the film. So, I had to make a decision whether to render detail in the shadow areas or the highlight areas. In this instance I exposed for the shadows.**

Using photographic filters

The art of photography is a clever combination of graphic design and managing light. In the latter of these two disciplines – light management – filters are essential tools. While there are many types of filter available some are used far more frequently than others and it is these that I will concentrate on in the following section.

The issue that you will face when photographing using a filter is how much light the filter absorbs. As a rule of thumb, the darker the filter the more light is lost. If you are metering with a TTL meter then the problems are somewhat negated. Because the camera is measuring the amount of light actually entering the lens it will automatically take into account any filters you have in place... in theory. As with every rule, however, there are exceptions, which I'll explain in a moment.

Table 11, below, indicates the level of exposure compensation required for some of the more popular single-tone filters, when metered with a non-TTL meter. When you are using a TTL meter the meter will automatically compensate for the light absorbance of the filters listed in this table.

Not all filters are single tone and these need more thought when calculating exposure. By far the most complex filter is the polarizing filter, used particularly by landscape photographers. The linear-type polarizing filter is also the exception to the rule I mentioned above.

TABLE 11 — SINGLE-TONE FILTERS

Colour 81 series	81A	81B	81C	81D
'warm'	+1/3	+1/3	+1/3	+2/3
Colour 82 series	82A	82B	82C	82D
	+1/3	+1/3	+2/3	+2/3
B&W	Light Red	Yellow	Orange	Yellow/Green
	+2	+1/3	+1	+1½

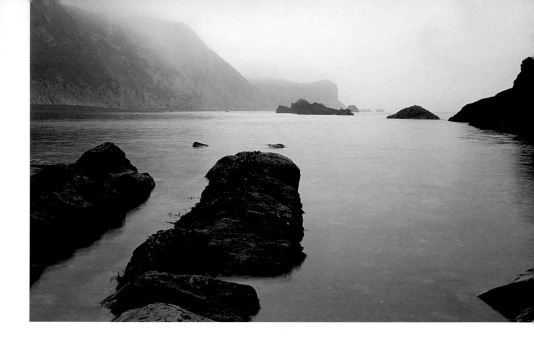

Polarizing filters

There are two types of polarizing filters – linear and circular. A TTL meter will, again, automatically compensate for any light loss when using a circular polarizer. However, because of the design of the linear-type polarizer even a TTL meter will be baffled.

The purpose of a polarizing filter is to block polarized light from entering the lens, and subsequently from reaching the photographic recording material. Depending on the position of the filter it will block more, or less light, which ultimately affects the amount of exposure compensation required.

When using a linear-type polarizer and/or metering with a non-TTL meter, use table 12, right, to calculate the amount of exposure compensation required. These values should be used as a guide only and, because calculating exposure when using a polarizing filter is not an exact science, I would recommend bracketing a 1/3 or 1/2 of a stop on either side.

TABLE 12

POLARIZING FILTERS

Polarization	Exposure compensation
1/4	1/2 stop
1/2	1 stop
3/4	1½ stops
Full	2 stops

Above **A polarizing filter helped to saturate the colour of this emerald lake in Tongariro National Park, New Zealand. At full polarization I added two stops of light to the exposure settings and bracketed a 1/2 stop either side, just to be safe.**

35mm panoramic camera, 45mm lens, Fuji Velvia, polarizing filter, 1/60sec at f/16

Graduated neutral density filters

Graduated neutral density (GND) filters are most often used in landscape photography where frequently the difference in tone between the sky and the land is quite pronounced. When this difference is outside the latitude of the film or sensor you will lose detail in either the bright or shadow areas. For example, if you meter for the sky the landscape itself will come out underexposed and if you meter for the landscape the sky will be overexposed. GND filters prevent this by allowing you to darken the sky without changing its natural colour, so that its brightness is closer to the tone of the landscape. Because the SBR depends on the scene GND filters come in different strengths between one and three stops in 1/2 stop increments. They can also be used together to achieve strengths beyond three stops.

TABLE 13 — **f-STOP INDEX**

Filter type	Strength
GND 0.3	1 stop
GND 0.45	1½ stops
GND 0.6	2 stops
GND 0.75	2½ stops
GND 0.9	3 stops

Above **To even the tones between the sky and the foreground I added a neutral density graduated 0.6 filter (2 stops) to this scene. Without it the sky would have become washed out and lacking in detail.**

Below **The SBR between the sky and the foreground was quite large. I added a total of four stops'-worth of neutral density graduated filters, yet some of the sky has still overexposed.**

USING GND FILTERS WITH TTL METERING

When using a GND filter with a TTL meter you must meter the scene without the filter in place in front of the lens. Metering with the filter in front of the lens will give a technically inaccurate reading and defeat the object of its use. You will also need to ensure that the camera is set to manual exposure mode. The technique for calculating the strength of GND filter required is outlined below:

1 Take a meter reading for the landscape and place it in the appropriate zone on the grey scale.

2 Then, take a meter reading for the sky and, again, place it in the appropriate zone on the grey scale.

3 The number of zones between the two marks will indicate the difference in stops. You can then use this to decide the strength of filter needed to even out the tones.

So, for example, let's say that you meter the landscape and your meter's reading indicates a zone value of 5 – medium tone (see illustration **X**).

Next, the meter reading for the sky indicates a zone value of 8 (see illustration **Y**).

The difference in SBR is three zones, equal to three stops. So, placing a three stop GND filter over the area of sky you effectively evens the tones across the image, in this example, placing the sky in zone 5, the same zone as the landscape (see illustration **Z**).

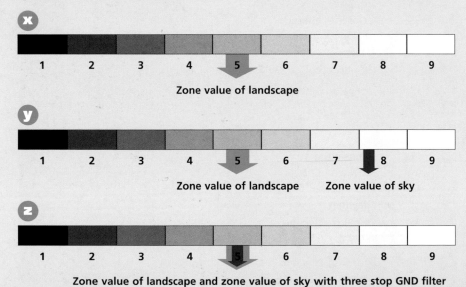

x

| 1 | 2 | 3 | 4 | 5 | 6 | 7 | 8 | 9 |

Zone value of landscape

y

| 1 | 2 | 3 | 4 | 5 | 6 | 7 | 8 | 9 |

Zone value of landscape Zone value of sky

z

| 1 | 2 | 3 | 4 | 5 | 6 | 7 | 8 | 9 |

Zone value of landscape and zone value of sky with three stop GND filter

Photographing close-ups

Macro and close-up photography often involves the use of extenders, either in the form of extension tubes or bellows. While these accessories allow you to focus more closely to your subject they also reduce the amount of light reaching the film or sensor, which, in turn, affects your exposure – and the longer the extension the greater the reduction in light. It's much like a tunnel: the further into the tunnel you travel the less light there is.

Metering for close-ups using a TTL meter overcomes any problems you may otherwise face because it automatically compensates for the loss of light. Using a TTL meter in close-up work means you can meter as for any other subject.

Top right **TTL metering works in exactly the same way for close-up photography as it does for normal photography, and will automatically take into account any accessories used, such as extension tubes.**

35mm camera, 50mm lens, extension tubes, Fuji Velvia, 1/60sec at f/16

Right **Correctly exposing to avoid black backgrounds when photographing close-up images requires skill. Using fill-in flash with daylight, together with the slow-sync flash application helps to balance the foreground and background.**

35mm camera, 105mm macro lens, Fuji Velvia, 1/30sec at f/22

CALCULATING COMPENSATION FOR CLOSE-UPS

If you are using a hand-held meter or, indeed, the 'sunny f/16' rule then you will need to calculate the level of compensation required. This is best done by determining the relevant extension/compensation factors for the close-up equipment you are using. To calculate the necessary exposure compensation copy these six steps.

1 First focus your lens at infinity. If you have an autofocus camera the best way to do this is by switching to manual focus and using the focusing ring yourself.

2 Attach your camera to a tripod to maintain a constant distance.

3 Now point your camera at an even surface, such as a wall. It is important that the surface is not just even in shape, but also in tone. This means that the level of light falling on it must be consistent.

○○○○○ 5 ○○○

4 Take a meter reading from the even surface. Your first meter reading will be taken as the base of your calculations (write this down as you don't want to go through the whole process again).

5 Without moving the camera-to-subject distance, set the lens to its closest focusing distance – if you want to find the lens compensation factor – or add an extension tube – if you want to find the extension tube compensation factor. It's very important that the camera remains still while you do this.

6 Now take a new meter reading and record the change in exposure. The difference between your first exposure and second exposure is the compensation factor for that lens or extension tube.

For example, say your first meter reading was 1/125sec at f/8 and your second meter reading was 1/90sec at f/8. The difference between the two readings is 1/2 stop. Now, every time you use that extension tube with the lens set at infinity you know to add an extra 1/2 stop of light. To calculate the exposure compensation factor for other accessories, repeat the process.

So what happens if you focus your lens at its minimum focusing distance? Well, the same issues apply. Because you have extended the distance between the front of the lens and the film plane/sensor you are reducing the amount of light reaching the film. To calculate the compensation factor for your lens you need to run another test.

Using the example described here, let's now assume you want to crop in and set the lens to its nearest focusing distance. To calculate the exposure compensation factor simply add the two values together. For example, if the compensation factor for your extension tube is 1/2 stop and for your lens is one stop, then the total compensation factor will be 1½ stops.

If you are using different lenses you will need to repeat this process with each lens you use. Once done, however, you can keep a record and use it on subsequent shoots.

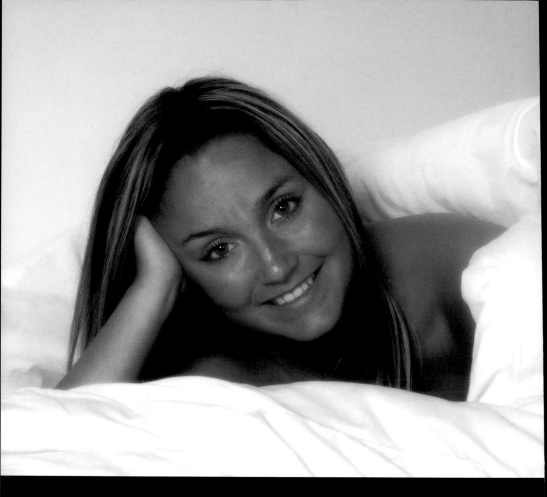

Flash exposure

6

So far, I have concentrated on calculating exposure under natural light conditions. So what happens when you add your own light source into the equation?

TTL-flash metering

Today's dedicated flash units are extremely sophisticated and a camera's TTL-flash metering systems highly accurate. This doesn't just apply to the top end of the market. Many cheaper flash units and metering systems have benefited from the advances made with professional models.

In the past, flash units would discharge at full power irrespective of the circumstances. This would leave all of the calculations in the hands of the photographer. Now that has changed and most modern systems work by discharging only the correct amount of light for your exposure settings and the prevailing shooting conditions.

However, as with normal TTL metering the amount of light discharged is set to render your subject as mid-tone. And, as we've already seen, this may not be appropriate. So how do you go about compensating for flash exposure?

Well, first of all you may find that your flash unit or your camera allows you to set a compensation factor to flash exposure settings in much the same way as you do for your non-flash exposures. If this is the case then you can use the same colour scales, to determine the amount of compensation that you need to render a subject the correct tone, that appear on page 85.

Below **Working in a studio allows you to play God with light but, once again, it is how you control exposure that adds sparkle to your pictures.**

35mm D-SLR, 80mm lens, 1/125sec at f/8.

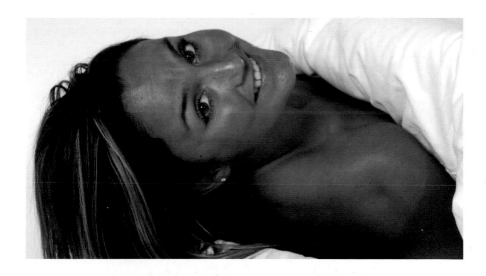

Above and left **The eagle owl pictured above is a darker-than-mid-tone subject, being approximately one stop darker than the 18% average. If I had taken this photograph with the flash unit set to zero compensation, then the resulting image would have appeared lighter (as illustrated by the smaller image). To get the exposure right I had to add minus one stop compensation, which reduced the amount of light emitted by the flash unit resulting in a faithful exposure of the owl's feathers and, most importantly, its eyes.**

○○○○○⑥○○

Manual flash exposure calculation

If you are working with less sophisticated flash and camera systems then you will need to understand how to calculate flash exposure manually, rather than leave it to chance.

Flash exposure is calculated using the flash-to-subject distance, as opposed to camera-to-subject distance (which is how you calculate non-flash exposure). Of course when you use a flash unit mounted on the camera's hotshoe these distances will be the same. If the flash is too far away from the subject then too little, or even no light, will reach it and the final image will come out underexposed. So what you need to do is get the subject within range of the flash

unit. The question is, 'How do you work out what that range is?'

Firstly, you will need to know what the guide number (GN) of your flash unit is. The guide number is given by the manufacturer and refers to the maximum operating distance of the flash unit at a given ISO. The guide number is normally given for ISO 100 film.

Once you know the guide number and the base ISO rating then it is a simple step to calculate the guide number for different film speeds. To do this it is best to work in stops, unless you are a complete

Below **If the flash unit is too far from the subject then too little light will cause the picture to be underexposed.**

Above **Moving the flash unit closer will allow you to achieve an exposure that is faithful to the subject.**

mathematical wizard, using the f-stop series of numbers. For example, let's say your flash has a guide number of 160 for ISO 400 film. To calculate the guide number for, say, Fuji Velvia 50 film, first calculate the difference in stops in film speed. Fuji Velvia 50 is three stops slower than ISO 400 film. For the purpose of calculation, drop the zero from the original guide number (160) giving you 16 and apply this to the f-stop scale: f/16. Now, open up three stops from f/16 (because of the slower film speed) and you have f/5.6. Then add the zero that you dropped earlier in the calculation. This gives a guide number of 56.

Once you know the correct guide number for the film (or ISO equivalency) you're using, you can calculate flash-to-subject distance using the following formula:

> **Flash shooting distance = Guide Number (GN) / f-stop (aperture)**

For example, if your guide number is 56 (as per the above example) and your aperture is f/8 then your flash shooting distance should be 7 feet (2.13 metres). Once you have this base calculation you can determine where to position the flash based on your preferred exposure settings (as shown in illustration **X,** opposite).

Taking the above example a step further, let's say you want to shoot at f/11 rather than f/8. Where do you position the flash unit? Simple,

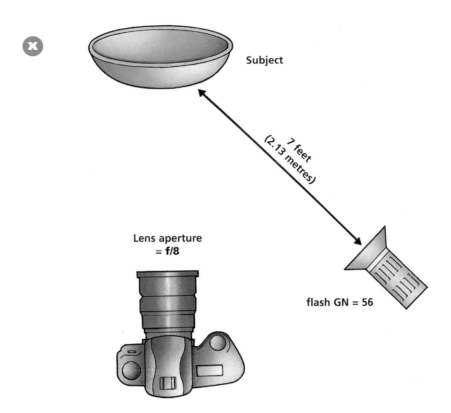

X

Subject

7 feet
(2.13 metres)

Lens aperture
= **f/8**

flash GN = 56

using the above formula 56 (GN) divided by 11 (lens aperture) equals 5 feet (1.52 metres) (as shown in illustration **Y**).

What happens when you are unable to move the flash unit closer? In this situation you need to calculate the required lens aperture. You can do this by rearranging the formula above to become:

**f-stop (aperture) =
Guide Number (GN) /
flash-to-subject distance**

For example, let's say you are 16 feet (4.88 metres) from the subject and the guide number of your flash unit is 56. Using the new formula, 56 (GN) divided by 16 (flash-to-subject distance in feet) equals 3.5, giving you an aperture of f/3.5 (as shown in illustration **Z,** page 123).

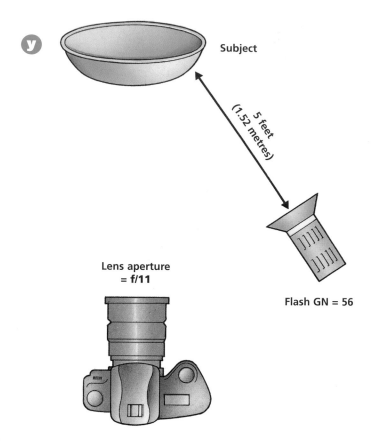

y

Subject

5 feet
(1.52 metres)

Lens aperture
= f/11

Flash GN = 56

Exposure calculation for bounced flash

There may be occasions when you want to bounce flash off a wall or ceiling to soften the quality of light or make the light source larger. When you bounce flash using an automatic TTL flash unit then the same exposure calculations apply as above. This is because the camera is measuring the light entering through the lens and so will automatically take into account the extra distance the light is travelling and any absorption factor of the surface the flash is bounced off. Similarly, non-TTL automatic flash will work perfectly well so long as the sensor on the flash unit is pointed towards the subject.

However, if you are calculating flash exposure manually then you will need to change a couple of things. Firstly, you must calculate

6

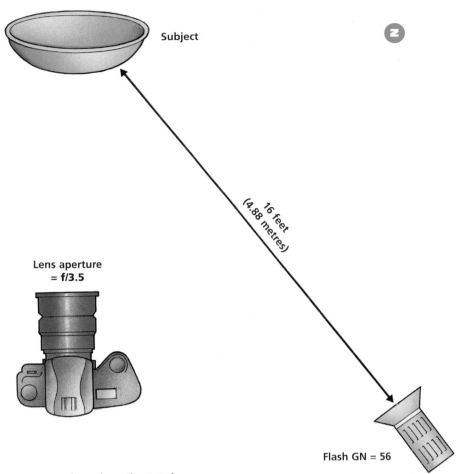

Subject

16 feet
(4.88 metres)

Lens aperture
= f/3.5

Flash GN = 56

your exposure based on the total
distance the flash has travelled.
That is the distance from the flash
unit to the reflective surface plus
the distance from the surface to the
subject. You will also need to
compensate for light loss caused by
absorption and scattering.

Exposure calculation for diffused flash

When you place a diffuser in front of your flash unit, the flash-to-subject distance won't change but you will lose some light through absorption. As with bounced flash, TTL-auto and non-TTL-auto flash units will automatically compensate for this loss of light. When calculating flash exposure manually, however, you will need to run some tests in order to measure the amount of light absorbed by the diffuser material (see 'The Absorption Test', opposite).

For example, if your base lens aperture was f/16 and your correctly exposed test shot was taken with an aperture of f/11 then the difference between the two is one stop. Now, every time you use that particular diffuser you know to add one stop exposure compensation.

While it is possible to write an entire book on flash exposure, what I have discussed here should be sufficient for all but the most complicated of shooting situations. Like the question of exposure in general, its not as complicated as it seems!

FLASH AND DIGITAL PHOTOGRAPHY

Digital photography has presented a new series of problems for flash-lit exposures. The characteristics of a digital sensor are very different from those of film and using a flash that is designed for a film camera with a digital camera can result in regular under- or overexposure. There are two things that you can do to correct this. Firstly, and most simply, buy a dedicated flash unit – one that is designed for use with your digital camera. Secondly, as you may not want to spend the money on a new unit, use a process similar to that on page 61 to work out by how much your flash unit is under- or overexposing. Then every time you use that flash unit dial in the correct amount of compensation – because the problem is caused by the difference in media this amount should remain the same from shot to shot.

THE ABSORPTION TEST

1 With your camera mounted on a tripod and a flash unit attached, compose your picture.

2 Take a picture without the diffuser attached to the flash unit, using the manual flash exposure calculations described earlier. Make a note of the exposure settings – this will be your base aperture.

3 Without moving the camera, attach the diffuser to the flash unit and take several more shots, opening the aperture by a 1/2 stop for each additional frame. Make a note of the aperture for each picture.

4 Ascertain which of the images is correctly exposed, refer to your notes and check the aperture used for that frame. The difference in stops between this aperture and the base aperture is the absorption value of the diffuser.

Right **Some flash units, like the Nikon SB-800, are sold with a variety of accessories including diffusers. In order to get the most accurate exposures possible, follow the steps above to find the absorption value of your diffuser.**

7 Post camera exposure

The focus of this book, and everything I have covered
so far, is on achieving faithful exposures in-camera.
And, I strongly urge you to aim for faithful exposures at the point
of making the photograph. However, if things aren't quite right there are a
number of steps that you can take in the digital darkroom.

The digital darkroom

There are times when the shooting conditions and the limitations of film or sensor won't allow you to achieve the images you want. While I do not intend to write reams on this particular subject, I think it is important to at least cover the basics of what to do when the image coming out of the camera doesn't quite live up to your expectations.

It's important to understand that I am not talking about image manipulation. I strongly believe that rubbish in equals rubbish out and that no amount of doctoring will rescue a photograph that is poor in

Below **Photography is, and has always been, a two-part process – image capture and image processing. Today, the secrets of the darkroom, such as selective exposure, un-sharp mask and managing contrast, are terms familiar to us all thanks to photo-enhancement software and computers.**

35mm camera, 24mm lens, Fuji Velvia, 1/10sec at f/32

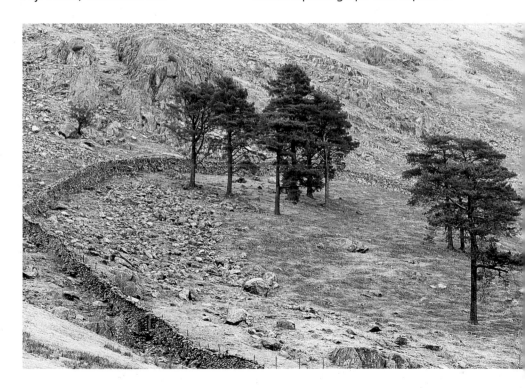

the first instance. What I am discussing is how to compensate for the limitations all photographers have to work with when the tools needed for in-camera adjustments are unavailable to you or the conditions imposed upon you are not suitable for making the kind of exposure that you want to.

Historically images would have been enhanced in the darkroom using selective printing techniques, such as those mastered by Ansel Adams and written about in his series of books *The Camera*, *The Negative* and *The Print*. This is a huge and varied subject, and there is a lot to be said for the hands-on enjoyment of the darkroom. However, the advent of modern technology and the expanding role of computers in photography means most post camera production is now made on the computer using specialized software, such as Adobe PhotoShop.

It would require a complete book, and possibly several volumes, to cover the subject of software-based image enhancement in full. My aim here is to simply outline some of the basic functions available in such software programs.

Controlling contrast

As I have already discussed, an image's contrast is measured by the grey scale. For an image to have a good tonal range (and therefore good contrast levels) it needs to make use of the full range of tones from black to white. When an image lacks tonal range it appears flat and uninteresting.

Using the 'levels' dialogue can alter the level of contrast in an image. This function uses a representative histogram to show the number of pixels at different brightness levels in an image and allows for the brightness of each pixel to be remapped so the darkest point corresponds to black and the brightest point to white. In a picture that lacks any real contrast, follow the steps set out opposite. By opening the 'levels' dialogue box in Photoshop you can see that the range of tones falls short of the entire range available – 0 (black) to 255 (white).

USING THE LEVELS DIALOGUE BOX TO INCREASE CONTRAST

1 First open the levels dialogue box – this can normally be found under the image tools list. You will see a histogram which serves as a visual guide of the 'key tones'.

2 Re-map the shadows and highlights, by dragging the left-hand slider to the point where the histogram values cross zero at the bottom, and the right-hand slider to that point at the top.

The result of this exercise is that the brightest pixels in the image are now mapped to white and the darkest pixels to black.

3 Finally, you can use the middle slider to change the level of the middle tones in the image without affecting the highlights or shadows to any great extent. You can experiment with this final phase until you get an image that you like.

The image now has a better tonal range than the original. This results in a stronger and more pleasing picture.

Controlling colour

As well as adjusting the contrast of your image you can use the 'levels' dialogue box to counteract colour problems caused by either poor calibration, incorrect white balance or wrong film type.

Having defined the black and white points in an image you can tell the software exactly where in the picture these points are by using the black, grey and white eyedroppers. What this will now do is re-map the colour of the pixels.

You should be aware that without a properly calibrated computer monitor – which most people don't have – it is very difficult to make accurate changes using this tool.

It also saves you a lot of time fiddling around with the 'levels' dialogue box, if you can work out what went wrong with the original exposure. This way you can correct a specific problem, rather than take a haphazard approach.

Finally, it is worth noting that colour adjustments can look very seductive when they are first made, only to look totally unrealistic when they are reviewed at a later date.

First, select the black eyedropper, move it to the darkest point of the image and click on that point.

Then, select the white eyedropper, move it to the brightest part of the image where detail is visible and click on that point.

3 Finally, to define the grey point, select the grey eyedropper, drag it to a point on the image that should appear middle-tone grey and click on that point.

The resulting picture (below) **has a better colour balance than the unadjusted image** (right).

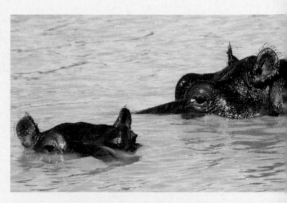

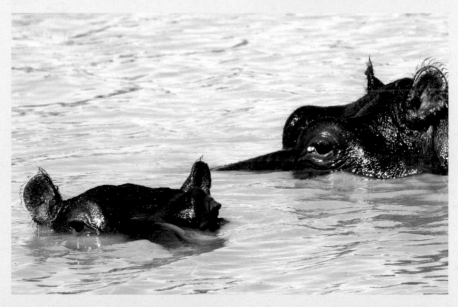

Selective exposure

The 'levels' dialogue is an excellent application for adjusting the overall brightness of a scene. But what happens when you want to adjust very specific areas of an image?

The old darkroom technique of 'dodging and burning' (giving different areas of the scene more or less exposure to lighten or darken them) is available via the computer.

Using the dodging tool will lighten selected areas of the scene while the burn tool will darken selected areas.

By using these tools selectively you can enhance the contrast of an image. You can also alter the size of the paintbrush so that you can be more precise.

In the example below some areas of the grassland have been 'dodged' to add highlights, while shadow areas underneath the wildebeest have been 'burnt-in' to maintain contrast. Compare the two images and the bottom image should have a much greater impact than the image on the left.

Left and Below **The image to the left is lacking contrast. The difference between the highlights and shadows is not great enough to give the photo impact. The image below has been 'dodged and burned' to enhance the final contrast.**

Magic wand

You can also use the magic wand to brighten shadow areas or darken highlights in an image, without affecting the base exposure for the main image. Using the picture below as an example, the light shining on the left side of the lion's face is overexposed compared with the main image. By selecting the magic wand function in Photoshop and clicking on the affected area you can use the levels tool to darken the highlights.

Right **The light falling on the left-hand side of the lion has overexposed this part of the image. The base exposure is fine (as you can see from the rest of the image), so the magic wand is the best tool to use.**

Below **The image of the lion now has a more even exposure – compare the left-hand side of the image to the image on the right. This has enhanced the impact of the image as a whole.**

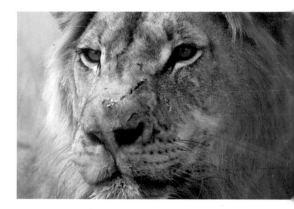

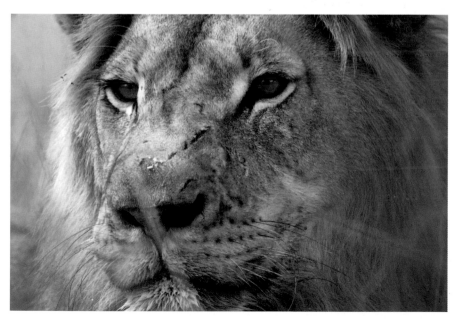

Glossary

18% grey The middle point between films' ability to read detail in featureless black and featureless white.

81 series filter A filter type that produces a warm colour cast by reducing the level of blue light reaching the film.

AE *see* Automatic exposure.

AF *see* Autofocus.

Ambient light The available light by which to take photographs.

Angle Of View The area of a scene that a lens takes in. A wideangle lens, such as 28mm, has a wide angle of view. A telephoto lens, such as 300mm, has a narrow angle of view.

Aperture The hole or opening formed by the metal leaf diaphragm inside the lens or the opening in a camera lens through which light passes to expose the film. The size of the aperture is denoted by the f-numbers.

Aperture priority An exposure mode on an automatic camera where the photographer sets the aperture and the camera sets the shutter speed for proper exposure.

If the aperture is changed, or the light level changes, the shutter speed changes automatically.

Aperture ring A ring, located on the lens barrel, which is linked mechanically to the diaphragm to control the size of the aperture.

Artificial light Light from a man-made source, such as a flash unit, household bulb, fluorescent tube or strobe light.

ASA American Standards Association. Group that determined the numerical ratings of speed for US-manufactured photosensitive products such as camera film.

Autoexposure bracketing A setting on the camera whereby the camera will automatically adjust the initial exposure setting by a pre-defined amount (usually around 1/3 or 1/2 stop) for one, two or more exposures of the same scene.

Autofocus (AF) System by which the focusing function is automatically managed by the camera.

Automatic camera A camera with a built-in exposure meter that automatically adjusts the lens opening, shutter speed, or both for correct exposure.

Automatic exposure (AE) The setting on a camera whereby the camera selects the appropriate lens aperture/shutter speed combination for a correct exposure, given the meter readings it has taken.

Back lighting Light coming from behind the subject, towards the camera lens.

Balanced fill-in flash A type of TTL auto flash operation, which uses the camera's exposure meter to control ambient light exposure settings, integrated with flash exposure control. It is used to lighten or 'fill-in' the shadow areas of an image.

Bellows The folding portion in some cameras that connects the lens to the camera body. Also a camera accessory that, when inserted between the lens and camera body, allows variable extension of the lens-to-film distance for close focusing or macro photography.

Bracketing The process of exposing a series of photographs of the same subject at different exposures.

(B)ulb setting A shutter-speed setting on an adjustable camera that allows for timed exposures. When set on B, the shutter will stay open as long as the shutter release button remains depressed.

Burning-in A darkroom technique that gives additional exposure to part of the image projected on an enlarger easel to make that area of the print darker.

Camera shake Movement of camera caused by unsteady hold or support, vibration, etc., leading, particularly at slower shutter speeds, to a blurred image on the film.

Cast Abnormal colouring of an image produced by departure from recommended exposure or processing conditions with a transparency film, or when making a colour print.

CCD (charge-coupled device) A microchip made up of light-sensitive cells and used in digital cameras for recording images.

Centre-weighted metering A type of metering system that apportions a high level of the exposure calculation on the amount of light falling at the centre of the picture space. This is suitable for portraits or scenes where subjects fill the centre of the frame.

Close-up A picture taken with the subject close to the camera, usually less than two or three feet away.

Close-up lens A lens attachment placed in front of a camera lens to permit taking pictures at a closer distance than the camera lens alone will allow.

CMOS (complimentary metal oxide semi-conductor)
A microchip made up of light-sensitive cells and used in digital cameras for recording images.

Colour temperature Description of the colour of a light source by comparing it with the colour of light emitted by a theoretical perfect radiator at a particular temperature expressed in Kelvins (K).

Composition The arrangement of the design elements within the picture space.

Contrast The range of difference between the highlight and shadow areas of a negative, print, slide or digital image.

Cropping Printing only part of the available image from the negative, slide or digital file, usually to improve composition.

Depth of field The zone of acceptable sharpness in front of and behind the subject on which the lens is focused.

Diffuse lighting Lighting that is low or moderate in contrast, such as on an overcast day.

Dodging Holding back the image-forming light from a part of the image projected on an enlarger easel during part of the exposure to make that area of the print lighter.

Down-rating Applied to film speed, where the manufacturer's set film speed, measured in ISO, is manually reduced and the film is exposed at a slower film speed (e.g. an ISO 200 film can be down-rated to an ISO 100 film).

DX (digital index) Coding on the film cartridges used to transmit information in relation to film speed, the length of film and the exposure latitude to the camera.

EV (exposure value)
A measurement of light given by an exposure metre that enables exposure settings to be derived.

Exposure The quantity of light allowed to act on a photographic material.

Exposure compensation A level of adjustment given (generally) to autoexposure settings that adjusts for known inaccuracies in the camera's automatically chosen exposure settings.

Exposure latitude The range of exposures from underexposure to overexposure that produces acceptable images on a specific type of film.

Exposure meter An instrument with a light-sensitive cell that measures the light reflected from or falling on a subject, used as an aid for selecting the exposure setting.

Extension bellows Device used to provide the additional separation between lens and film required for close-up or macro photography.

Extension tubes Metal tubes used to obtain the additional separation between lens and film for close-up or macro photography.

f-numbers A series of numbers on the lens aperture ring and/or the camera's LCD panel that indicate the size of the lens aperture relative to the focal length of the lens.

f-stop A fraction that indicates the actual diameter of the aperture: the 'f' represents the lens's focal length, the slash means 'divided by', and the word 'stop' is a particular f-number.

Fill-in flash Method of flash photography that combines flash illumination and ambient light, but does not balance these two types of illumination. See also Balanced fill-in flash.

Film A photographic emulsion coated on a flexible, transparent base that records light.

Film latitude The range, measured in f/stops, between highlight and shadow that a film can record detail.

Film speed The sensitivity of a given film to light, measured in ISO.

Filter A piece of coloured glass, or other transparent material, used over the lens to emphasize, eliminate, or change the colour or density of the entire scene or certain areas within a scene.

Flash A form of artificial light generated by the full or partial discharge of a capacitor.

Flat lighting Lighting that produces very little contrast and minimal shadow.

Focal length The distance between the film and the optical centre of the lens when the lens is focused on infinity, measured in millimetres.

Focus Adjustment of the distance setting on a lens to define the subject sharply. Generally, the act of adjusting a lens to produce a sharp image.

Front lighting Light shining on the surface of the subject facing the camera.

Grain Minute metallic silver deposit, forming in quantity the photographic image on film.

Graininess The granular appearance of a negative, print, or slide. Graininess generally becomes more pronounced with faster film, and the degree of enlargement makes it more noticeable.

Grey card A grey card reflects 18% of the light falling on it, representative of a middle-toned subject.

High contrast A wide range of density in a slide, print, negative or digital file.

Highlight Very bright part of an image or object that is generally lacking in any detail.

Incident light Light falling on a surface.

ISO speed The international standard for representing film sensitivity. The emulsion speed (sensitivity) of the film as determined by the standards of the International Standards Organization.

Kelvin (K) A measurement of colour temperature.

Large-format A term referring to a negative or transparency with a size of 5" x 4" or greater.

LCD (liquid crystal display) panel A screen on a camera that provides information in the form of alphanumeric characters and symbols.

Lens One or more pieces of optical glass, or similar material, designed to collect and focus rays of light to form a sharp image.

Lens speed The largest lens opening (smallest f-number) at which a lens can be set.

Light meter *see* Exposure meter.

Macro lens A lens that provides continuous focusing from infinity to extreme close-ups, often to a reproduction ratio of 1:1 or 'life-size' (true macro), or sometimes larger.

Middle tone A tone of grey or any other colour that reflects 18% of the light falling on it.

Multi-segment metering An exposure metering system using a number of variable sized and positioned segments in conjunction with an in-camera computer to detect brightness levels and provide an exposure value based on pre-defined precedents.

Neutral density (ND) Usually applies to a filter used to reduce the level of light entering the lens without affecting the colour cast. Often these filters are graduated to allow variable amounts of light to pass through the lens's evening up different tones within a scene. These filters are grey in appearance.

Noise The digital equivalent of graininess, caused by stray electrical signals during long-time exposures or when making exposures at high ISO ratings.

Overexposure A condition in which too much light reaches the film or sensor, producing a dense negative or a very bright/light print or slide.

Photo-sensor (PS) The device that records light in a digital camera.

Polarized light Light waves vibrating in one plane only as opposed to the multi-directional vibrations of normal rays.

Polarizing filter A filter that transmits light travelling in one plane while absorbing light travelling in other planes. When placed in front of a camera lens, it can eliminate undesirable reflections from a subject such as water, glass, or other objects with a shiny surface. Also used to saturate colours (e.g. to make blue skies darker).

Program exposure An exposure mode on an automatic camera that automatically sets both the aperture and the shutter speed for proper exposure.

Push processing Increasing the development time of a film to increase its effective speed (ISO rating). Often used in low-light situations.

Pull processing Reducing the development time of a film to reduce its effective speed (ISO rating).

Reciprocity law A change in one exposure setting can be compensated for by an equal and corresponding change in the other. For example, the exposure settings of 1/125sec at f/8 produce exactly the same amount of light falling on the film or sensor as 1/60sec at f/11.

Reciprocity law failure At shutter speeds in excess of one second the law of reciprocity begins to fail because the sensitivity of film reduces over time. This affects different films to different extents.

Reflectance value The amount of light, given as a percentage, reflected by the surface of an object.

Sensitivity Expression of the nature of a photographic emulsion's response to light. Can be concerned with degree of sensitivity as expressed by film or sensor speed or its response to light of various colours, (spectral sensitivity).

Shutter A curtain, plate, or some other movable cover in a camera that controls the time during which light reaches the film.

Shutter priority An exposure mode on an automatic camera that lets you select the desired shutter speed; the camera sets the aperture for proper exposure. If you change the shutter speed, or the light level changes, the camera adjusts the aperture automatically.

Side lighting Light striking the subject from the side relative to the position of the camera.

Single lens reflex (SLR) A type of camera that allows you to see through the camera's lens as you look through the viewfinder. Other camera functions, such as metering and flash control, may also operate through the camera's lens.

Spot metering A metering mode that takes a light reading from a very small portion of the scene, often as little as 1°.

Standard lens A lens that gives an image a similar perspective to that of the original scene as seen by the human eye.

Stopping down Changing the lens aperture to a smaller opening. For example, from f/8 to f/11. Generally, used to mean any reduction in exposure either in aperture or shutter speed.

Subject brightness range (SBR) The exposure range between the lightest and darkest image area.

Telephoto lens A lens with a narrow angle of view.

Through-the-lens (TTL) metering A meter built into the camera that determines exposure for the scene by reading light that passes through the lens during picture taking.

(T)ime setting Similar to (B)ulb setting (T)ime is used for long exposures and requires the shutter-release button to be pressed once to open the shutter and once to close it.

Ultraviolet (UV) Part of the electro-magnetic spectrum, consisting of wavelengths shorter than light and therefore invisible to the eye but can be recorded by photosensitive material.

Underexposure A condition in which too little light reaches the film, producing a thin negative, a dark slide, or a muddy looking print or digital file. There is too much detail lost in the areas of shadow in the exposure.

Up-rating Applied to film speed, where the manufacturer's set film speed, measured in ISO, is nominally increased and the film is exposed at a faster film speed setting (e.g. an ISO 200 film can be up-rated to an ISO 400 film).

Wideangle lens A lens that has a shorter focal length and a wider field of view (includes more subject area) than a standard lens.

Zoom lens A lens with a variable focal length.

Zone system A system for calculating exposure designed by Ansel Adams.

Appendix

Useful companies:

Adobe
www.adobe.com – software

Canon
www.canon.co.uk – UK
www.usa.canon.com – USA
www.canon.com – Worldwide

Fujifilm
www.fujifilm.co.uk – UK
www.fujifilm.com – USA

Hasselblad
www.hasselblad.co.uk – UK
www.hasselbladusa.com – USA
www.hasselblad.se – Worldwide

Kodak
www.kodak.co.uk – UK
www.kodak.com – USA

Konica Minolta
www.konicaminolta.co.uk – UK
www.minoltausa.com – USA
www.konicaminolta.com – Worldwide

Lee Filters
www.leefilters.com – UK
www.leefiltersusa.com – USA

Leica
www.leicacamera.com – Worldwide

Mamiya
www.mamiya.co.uk – UK
www.mamiya.com – USA

Nikon
www.nikon.co.uk – UK
www.nikonusa.com – USA
www.nikon.com – Worldwide

Olympus
www.olympus.co.uk – UK
www.olympusamerica.com – USA
www.olympus.com – Worldwide

Pentax
www.pentax.co.uk – UK
www.pentaxusa.com – USA
www.pentax.com – Worldwide

Rollei
www.rollei.de – Worldwide

Sekonic
www.sekonic.co.uk – UK
www.sekonic.com – USA

Sigma
www.sigma-imaging-uk.com – UK
www.sigmaphoto.com – USA

General photography:

Natural Photographic
Wildlife photography and
photojournalism by Chris Weston
www.naturalphotographic.com

Photography publications:

Photographers' Institute Press
Photography books and magazines
www.gmcbooks.com

Index

action photography 20–1
Adams, Ansel 106, 128
Adobe PhotoShop 128, 133
angle of incidence 81
angle of view 78, 96
aperture 26, 49, 85, 86
aperture priority 28
artificial light 35, 40
autoexposure (AE) 28, 52
 meters 53
autofocus (AF) cameras 114

back lighting 43, 47, 96–7
bounced flash photography 122–3
bracketing 88, 89, 101
bright conditions 81, 91–5
 and digital sensors 25
 sunny f/16 rule 91–3
 sunny f/22 rule 94–5
bulb setting 20
burning-in 132

camera shake 87
CCDs (charge coupled devices)
 17, 107
centre-weighted metering 56, 75, 96
close-up photography 113–15
 calculating compensation 114–15
CMOS (complimentary metal oxide
 semi-conductor) 17
colour 31–2
 correction filters 32, 35, 35,
 36, 105
 digital processing control 130–1
 exposure guide 85
 temperature 33–4, 36
 visible spectrum 31–2

colour shift 105
contrast 38, 41, 74
 in digital photography/processing
 25, 132
 range 64
cropping 96, 115

depth of field 18, 19, 27, 85, 86, 87
diffused flash photography 124
diffused lighting 40, 41, 42
digital cameras 17, 27
 bracketing 88
 colour response 65
 exposure 25
 and flash photography 124
 ISO equivalency 17–18, 70
 sensors 23–4, 25
 SLRs 101
 WB settings 36
digital processing 127–33
dodging and burning 132
down-rating film 68, 70

electromagnetic spectrum 31, 31
EV (exposure value) 49, 51, 88
 numbers 51
exposure
 'correct' 27, 98
 digital processing 132–3
 test 83
 working with 26–7
exposure compensation 23, 71, 84,
 85, 91, 101, 114–15
 when using filters 108–12
exposure controls
 basic 15–16
 in digital cameras 25